Timing for Animation

Related Focal Press Visual Effects and Animation Titles:

The Animator's Guide to 2D Computer Animation
Hedley Griffin

Producing Animation
Catherine Winder and *Zahra Dowlatabadi*

Digital Compositing for Film and Video
Steve Wright

A Guide to Computer Animation: for TV, Games, Multimedia and Web
Marcia Kuperberg

Essential CG Lighting
Darren Brooker

Film Animation
Dan McLaughlin

Character Animation in 3D
Steve Roberts

Personal Animation: Create & Distribute Your Film
Steve Subotnick

For more information on Focal Press titles visit www.focalpress.com

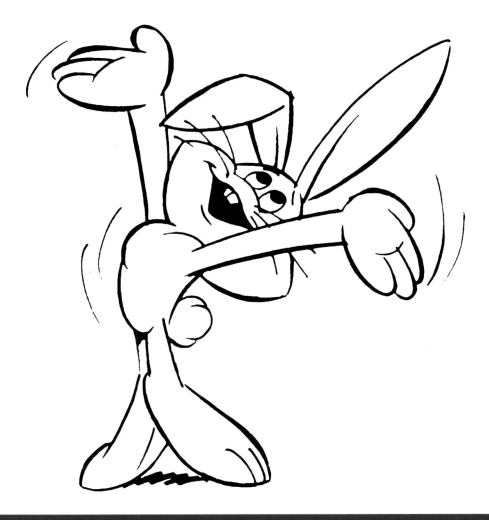

Timing for Animation

Harold Whitaker and John Halas
Updated by Tom Sito

ELSEVIER

AMSTERDAM • BOSTON • HEIDELBERG • LONDON • NEW YORK • OXFORD
PARIS • SAN DIEGO • SAN FRANCISCO • SINGAPORE • SYDNEY • TOKYO
Focal Press is an imprint of Elsevier

Focal Press is an imprint of Elsevier
Linacre House, Jordan Hill, Oxford OX2 8DP, UK
30 Corporate Drive, Suite 400, Burlington, MA 01803, USA

First published 1981
Reprinted 1990, 1997, 1999 (twice), 2000, 2001, 2002
Second edition 2009

British Library Cataloguing in Publication Data
Sito, Tom, 1956-
 Timing for animation. –2nd ed.
 1. Animation (Cinematography)
 I. Title II. Whitaker, Harold, 1920-
 778.5'347-dc22

Library of Congress Control Number: 2009926204

ISBN: 978-0-240-52160-2

For information on all Focal Press publications
visit our website at www.focalpress.com

Printed and bound in China

09 10 11 12 13 10 9 8 7 6 5 4 3 2 1

Contents

Contents

Contents

Foreword by John Lasseter, Pixar

I first became interested in animation as a kid. I watched every bit of it I could see, and found myself liking Disney animation and Warner Brothers cartoons more than most. I wondered what it was that set their work apart. As I learned more about animation I discovered that, arguably, it was their impeccable sense of timing.

Time is the essence of animation. It is what makes animation different to other visual arts where the observer controls how much time a piece of art is viewed. With animation the observer is captive, usually sitting in a theater, watching it play out in front of them. The animator controls how much or how little time is spent on the animation. Therefore, it's the animator's responsibility to control the timing of actions within the animation in order to capture the audience.

Timing gives meaning to movement. The proper timing of an action establishes the idea behind the action as well as the audience's interpretation of it. Timing also reflects the weight and size of an object, conveys a character's thought process and emotions, and strengthens story points.

When *Timing for Animation* was first published in 1981, I was an animator at Walt Disney Studios. Early on, I realized that the images in my head weren't translating onto the page exactly as I'd imagined. I would get caught up on a single drawing, erasing and reworking, but never quite capturing it. Hand drawn animation requires the ability to draw, and an understanding of motion and timing—how drawings change from one to another. *Timing for Animation* helped me focus solely on the timing aspects of animation and the importance of timing in the creation of quality animation.

However, the major impact of *Timing for Animation* was revealed to me when I began working in computer animation, where I was no longer inhibited by my drawing skills. Animation isn't about the single frame; it's about the motion as the whole. With computers you can cut and paste and iterate things over and over again. You can test things out without ever having to erase what you've drawn.

Never in the history of animation have we had tools with these kinds of iterative properties. With computer technology, I quickly learned more about animation and the movement of objects than ever before. It was then that I realized that the lessons in this book about the timing of animation are so important.

With computer animation software, anyone can make an object move. But getting the object to have a sense of weight, size, scale, motion and humor has to do with how you move an object. The computers don't create animation for the animator—the animator still needs knowledge of the principles of timing in order to make the computer animation come alive. With any type of animation, the goal is always to make a character look like it's thinking—that all of its movements are generated by its own thought processes. No software program is going to give you that.

In his preface to the 1981 version of *Timing for Animation,* John Halas said, '…this book is primarily confined to hand drawn animation which up to this point in film history still comprises 90 per cent of all output in the animation medium.' Times have certainly changed, in that now an awful lot of animation is done on computers, but the truth is that the principles of timing laid out in this book are more applicable than ever before.

The knowledge to be gained from Whitaker and Halas's *Timing for Animation* is just as relevant today as it was when it was first published and, in my opinion, even more so. I began sharing this book with colleagues in 1981, and continue to share it today in the hope of educating people who work with computer animation. This book shows just how essential principles like timing are for the art of animation.

Preface to 2nd edition

Whitaker and Halas's *Timing for Animation* has been a mainstay in the literature of animation instruction since its first edition was released in 1981. Sitting dog-eared and spine-split on desks and workstations around the world, it is the standard reference for all involved in making animation. This is true not only for those doing pure cartoons, but visual effects and interactive game design as well. Its only shortcoming is that it was originally written for a pre-digital age, so it offered few insights to the challenges of new media. With this update we will attempt to address this, and provide the animation novice—professional and fan alike—with a more complete look into the wonderful complexity that is modern animation and visual effects production.

I knew John Halas, and admired his work at the Halas & Batchelor Studio in the UK. John's writings were some of the first serious instructional works on creating animation I had read. Harold Whitaker was a top artist in the London animation scene, and was a mentor and teacher to a great many young animators. So, it was with understandable trepidation that I accepted the invitation from Focal Press to update this work. For those who have

FIGURE 1 On every table and workstation.

loved this book for so many years, fear not. It is not my intention to glue new arms on the Venus de Milo. Much of the original copy is undisturbed. I am merely adding notes to reflect some of the more modern practices that have changed animation since the first writing. George Bernard Shaw said Britain and America are two great nations divided by a common language. I will also try to clarify some differences in nomenclature between what is used in studios in the Anglo-Canadian Commonwealth and its Yankee counterparts. So Dope Sheets = Exposure Sheets, a Fade To = Dissolve, etc.

Being one who has watched the Digital Age evolve since its earliest experiments, I am also sensitive to not dating the material. Large books that have painstakingly explained software programs from the 1980s and 1990s are now considered quaint, but irrelevant. Animator Jim Hillin stated it nicely, 'In computers, today's groundbreaking innovation is tomorrow's screen saver.' The modern pace of technological development has become so rapid that some animators complain they must learn a new software system with each new project. So, I will not dwell on the nuances of a specific animation program. I even have to catch myself when I refer to the final product as a 'film', since many projects are now delivered as a digital file. Celluloid film itself has become an endangered species. When I now use the terms 'film' or 'filming', it will have to be in a more symbolic sense.

The strength of *Timing for Animation* is in its simplicity and directness to whatever purposes you put its principles. You will find that the precepts laid out between these covers are important to all who create a frame-by-frame performance, regardless of whether they use a stylus and digital tablet, clay, cut-outs, some form of live-actor performance capture, or a pencil and paper.

Hopefully, despite my fingerprints on the finish, *Timing for Animation* will continue to be a vital text for anyone who is serious about creating animated film.

Tom Sito
Hollywood, 2009

Preface to 1st edition

The passage of time has fascinated artists, scientists and theologians for thousands of years. Naturally they have attributed to it different interpretations, different implications and different conclusions. Nevertheless there seems to be general agreement on one aspect of time; that we are all conditioned by it and that, whether we like it or not, there is a time space into which we inevitably have to fit.

Einstein, among other well-known names in the world of science, made a special study of time in relation to his research in physics. His theory of relativity maintains that space and time are merely different aspects of the same thing. Since then other physicists have pointed out that objects can be moved backward and forward in space, but nothing can be moved back in time.

Another method of describing the concept of time is through the 'three arrows of time'. The first 'arrow' is thermodynamic and can be seen operating when sugar dissolves in hot water. Second, is the historical 'arrow', whereby a single-celled organism evolves to produce more complex and varied species. The third is the cosmological 'arrow' which is the theory that the universe is expanding from a 'big bang' in the past. This cosmic expansion cannot be reversed in time. While the principle of relationships between the 'time arrows' is still to be worked out on a scientific level, the actual application of it is constantly related to all work which utilizes it, such as music and the performing arts. In the latter it is one of the most important raw materials.

In terms of animation, the idea of film time is one of the most vital concepts to understand and to use. It is an essential raw material which can be compressed or expanded, and used for effects and moods in a highly creative way. It is, therefore, essential to learn and to understand how time can be applied to animation. The great advantage of animation is that the animator can creatively manipulate time since an action must be timed prior to carrying out the actual physical work on a film.

It is also essential to understand how the audience will react to the manipulation of time from their point of view. Time sense or 'a sense of timing', therefore, is just as important as color sense and skill of drawing or craftsmanship in film animation.

It has to be realized that while a performance on stage and on the screen requires a basic understanding of how timing works, this book is primarily

confined to hand drawn animation which up to this point in film history still comprises 90 per cent of all output in the animation medium.

My co-author, who has drawn the majority of illustrations in this book, is reputed to be one of the world's most skillful animators. I have had the privilege of working with him for 30 years and during this period he became the teacher of many outstanding animation artists of today.

The book itself has been in production for five years and contains several decades of painful experience. We hope it will be of value to the new generation of artists and technicians.

John Halas
London, 1981

Acknowledgements

I am grateful to Focal Press/Elsevier for giving me this opportunity, and my thanks to the Halas and Whitaker families for their cooperation. Also to Katy Spencer for heading the effort. I'd like to express my gratitude to Disney/PIXAR Studios, Barry Weiss and SONY/Imageworks, PBS (WGBH/Cookie Jar), Gregg and Evan Spiridellis of Jibjab; **John Hughes and Matt Derksen, Joe Ksander, Seth Cobb and Jaqueline Rosado of Rhythm & Hughes Studio**. I'd also like to note a number of top animation professionals whose advice, particularly on the differences between traditional animation drawing and 3D Digital techniques, has been extremely helpful. Namely Mark Farquhar, Dan Lund, Kevin O'Neill, Steve Wood, Paul Teolis, David Valera, Robert Crawford, legendary Disney effects animator Dorse Lanpher, and my wife Pat Sito. I'd like to also thank Brian Barsky of Cal St. Berkeley for his notes on the manuscript.

TS
2009

Introduction: General Principles of Timing

In a film, ideas must come over immediately to the audience. There is no chance to turn back, as with a book, and reread a section.

The 'readability' of ideas depends on two factors:

1. Good staging and layout, so that each scene and important action is presented in the clearest and most effective way.
2. Good timing, so that enough time is spent preparing the audience for something to happen, then on the action itself, and then on the reaction to the action. If too much time is spent on any one of these things, the timing will be too slow and the audience's attention will wander. If too little time is spent, the movement may be finished before the audience noticed it, and so the idea is wasted.

To judge these factors correctly depends upon an awareness of how the minds of the audience work. How quickly or how slowly do they react? How long will they take to assimilate an idea? How soon will they get bored? This requires a good knowledge of how the human mind reacts when being told a story. It is also important to remember that different audiences react in different ways. So, for instance, an educational film for children would be timed in a different way from an entertainment film for adults, which requires a much faster pace.

Animation has a very wide range of uses, from entertainment to advertising, from industry to education and from short films to features. Many modern live action fantasy films contain as much animation as a cartoon film. Motion picture visual effects, interactive games and websites are heavily dependent upon knowledge of animation techniques. Different types of animation require different approaches to timing.

Timing for TV Series

Because television production requires large amounts of screen time, TV animation has to be planned out carefully, with economy in mind. This approach is generally known as 'limited animation'. With limited animation as many repeats as possible are used within the 24 frames per second. A hold is also lengthened to reduce the number of drawings. As a rule not more than six drawings are produced for one second of animation. Limited animation requires almost as much skill on the part of the animator as full animation, since he or she must create an illusion of action with the greatest sense of economy.

Timing for Full Animation

Full animation implies a large number of drawings per second of action. Some action may require that every single frame of the 24 frames within the second

be animated in order to achieve an illusion of fluidity on the screen. Neither time nor money is spared on animation. As a rule only, TV commercials and feature-length animated films can afford this luxury.

Animation is expensive and time-consuming. It is not economically possible to animate more than is needed and edit the scenes later, as it is in live action films. In cartoons, the director carefully pre-times every action so that the animator works within prescribed limits, and this way does not waste time doing unnecessary drawings.

Ideally, the director should be able to view the rough tests of the film as it progresses, and so have a chance to make adjustments. But often there is no time to make corrections in limited animation, and the aim is to make the animation work the first time.

Timing in General

Timing in animation is an elusive subject. It only exists whilst the film is being projected, in the same way that a melody only exists when it is being played. A melody is more easily appreciated by listening to it than by trying to explain it in words. So with cartoon timing, it is difficult to avoid using a lot of words to explain what may seem fairly simple when seen on the screen.

Timing is also a dangerous factor to try to formulate—something which works in one situation or in one mood, may not work at all in another situation or mood. The only real criterion for timing is: if it works effectively on the screen it is good, if it doesn't, it isn't.

So if having looked through the following pages you can see a better way to achieve an effect, then go ahead and do it!

In this book we attempt to look at the laws of movement in nature. What do movements mean? What do they express? How can these movements be simplified and exaggerated to be made 'animatable' and to express ideas, feelings and dramatic effects? The timing mainly described is that which is used in so-called 'classical' or 'full' animation. To cover all possible kinds of timing in all possible kinds of animation would be quite impossible.

Nevertheless we hope to provide a basic understanding of how timing in animation is ultimately based on timing in nature and how, from this starting point, it is possible to apply such a difficult and invisible concept to the maximum advantage in film animation.

What is Good Timing?

Timing is the part of animation which gives *meaning* to movement. Movement can easily be achieved by drawing the same thing in two different positions and inserting a number of other drawings between the two. The result on the screen will be movement, but it will not be animation. In nature, things

do not just *move*. You can draw a circle and declare it to be anything from a soap bubble to a cannon ball. We the audience will only understand what it is when we see how it moves and interacts with its environment. Newton's first law of motion stated that things do not move unless a force acts upon them. So in animation the movement itself is of secondary importance; the vital factor is how the action expresses the underlying causes of the movement. With inanimate objects these causes may be natural forces, mainly gravity. With living characters the same external forces can cause movement, plus the contractions of muscles but, more importantly, there are the underlying will, mood, instincts and so on of the character who is moving.

In order to animate a character from A to B, the forces which are operating to produce the movement must be considered. Firstly, gravity tends to pull the character down towards the ground. Secondly, their body is built and jointed in a certain way and is acted on by a certain arrangement of muscles which tend to work against gravity. Thirdly, there is the psychological reason or motivation for their action—whether they are dodging a blow, welcoming a guest or threatening someone with a revolver.

A live actor faced with these problems moves their muscles and limbs and deals with gravity automatically from habit, and so can concentrate on acting. An animator has to worry about making their flat, weightless drawings move like solid, heavy objects, as well as making them act in a convincing way. In both these aspects of animation, timing is of primary importance.

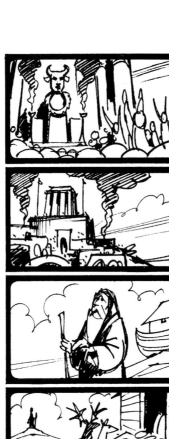

Fade in image of false god with people worshipping it.

Narration: "God saw how corrupt the earth had become, - "

Zoom back to long shot corrupt-looking city.

" - for all the people on earth had corrupted their ways."

Pan and track to Noah. (Ark already built in background)

"So God said to Noah - "

Mix to animals going up ramp two by two.

" - 'Bring into the ark two of all living creatures, male and female - "

Closer shot of animals going up ramp.

" - to keep them alive with you'".

Mix to birds flying in two by two.

"Two of every kind of bird - "

FIGURE 2 Part of the working storyboard of *The Story of the Bible* by Halas & Batchelor. At this stage the director works out the smooth visual flow of the film, the editing, camera movements, and so on. All these elements combine to tell the story in an interesting way.

The Storyboard

A smooth visual flow is the major objective in any film, especially if it is an animated one. Good continuity depends on coordinating the action of the character, choreography, scene changes and camera movement. All these different aspects cannot be considered in isolation. They must work together to put across a story point. Furthermore the right emphasis on such planning, including the behavior of the character, must also be realized.

The storyboard should serve as a blueprint for any film project, and as the first visual impression of the film. It is at this stage that the major decisions are taken as far as the film's content is concerned. It is generally accepted that no production should proceed until a satisfactory storyboard is achieved and most of the creative and technical problems, which may arise during the film's production, have been considered.

There is no strict rule as to how many sketches are required for a film. It depends on the type, character and content of the project. A rough guideline is approximately 100 storyboard sketches for each minute of film. If, however, a film is technically complex, the number of sketches could double. For a TV commercial, more sketches are produced as a rule because there are usually more scene changes and more action than in longer films.

Traditional Storyboards

The original form of storyboards originated in the 1920s, when artists would pin up their gag ideas on a corkboard on the wall. The idea quickly expanded and a specialist arose: the gag-man or storyboard artist. He or she would create a continuity of drawings delineating the cinematic flow of the film project to come. All the starts and stops of a potential character's actions would be spelled out in a series of sketches. These drawings could be 'pitched' or discussed openly in story-sessions, then photographed and matched to a rough soundtrack to further clarify what the final film might look like. These storyboard films have been referred to in the past with various names: the Animatic, Workreel, Storyreel or Leica reel.

The finished quality of the artwork varied according to the demands of the project. A storyboard only to be seen inside the company by the creative staff could be drawn quick, rough, and to-the-point while a storyboard to be shown to commercial clients or other outsiders, not used to rough drawings, would be highly polished and slick. Filmmakers have added accents like elaborate soundtracks, temporary background music and after-effects technology to 'sell the idea' of the film.

The important point is to convey an idea of the flow of the narrative, and to explore the visual possibilities for additional drama or humor. Live action filmmakers, from Cecil B DeMille to Steven Spielberg, have relied upon storyboards to anticipate potential problems and grasp the impending

production issues of a film. This way they could formulate a strategy long before expensive shooting with full crew, movie stars and location permits commenced.

Live action storyboards tend to emphasize frame composition and mis-en-scene or cinematic narrative, and do not focus upon the individual actor's performance. Some actors make it a personal rule not to look at storyboards so as not to be influenced. That's why, in live action storyboards, the figure's individual performances are downplayed. By contrast, storyboards for animated films place great emphasis upon the character's performance and what they are thinking or feeling.

In live action, the unit of the film known as 'the scene' can be made up of dozens of individual shots and can last a few minutes, for example Alfred Hitchcock's shower scene from the film *Psycho*, while in an animated film each individual cut is called a 'scene' and the sum of all these cuts constitutes a 'sequence', like the 'under the sea' sequence in Walt Disney Pictures' *The Little Mermaid*. In television production, the emphasis of storyboards is on economy: many reused scenes, simpler staging than a theatrical, relying on the dialog to carry a story more than complex pantomime action.

FIGURE 3 From Disney/PIXAR's *A Bug's Life* drawn by Nate Stanton and Joe Ranft. The storyboard drawings themselves are quickly done and easily replaceable, but contain all the essentials of the movement in each scene. (Copyright ©1998 Disney Enterprises, Inc/PIXAR.)

Digital Storyboards

Since the 1990s, computers have become part of the storyartists' tools. In the past, traditional storyboards were sent out to be photographed by a cameraperson using a down-shooter or rostrum camera (UK), and then the film was developed, cut together and matched to a soundtrack by an editor. This was a process that took several days at its fastest. Now, the storyartists alone have the power to create storyreels on their laptop computers, with multiple soundtracks and effects, all with an instantaneous playback.

This opens up new possibilities, but it also places increased responsibility upon the storyartist. He or she has to be much better versed in film editing and composition. There is no longer a quality control person to double-check for numerical errors or drawings out of order. The artist has to spend more time tightening and rendering the drawings, as well as additional digital effects and sound effects.

There are many off-the-shelf storyboarding programs that are introduced each year, and large studios customize their own proprietary programs. Most programs can be classified into the categories of 2D and 3D.

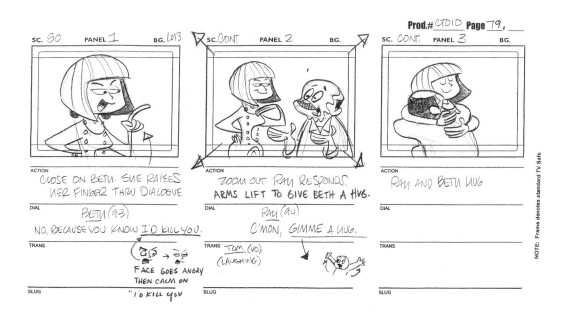

FIGURE 4 A Storyboard page drawn by Karl Toerge with director's notes added. From *Click & Clack's As the Wrench Turns* (2008). (Copyright © CTTV LLC.)

2D Storyboarding

This is a system where the drawings are still done on paper. They are then digitized into the computer and placed in order in the allotted time slots of the storyboard show file. This system can be used for so-called 2D animation programs like *Flash* and *Toon Boom*, as well as for films using 3D animation techniques like *Maya*.

Many of these storyboard packages now allow for drawing your storyboards directly into the computer by using a tablet and digital stylus rather than a pencil and paper. The first tablets were a challenge to learn—they left no image on the drawing surface and the screen image appeared after an interval of time, which proved tedious.

Current models are much faster and simpler for the artist to use. You can also set the frame size to stage shots for a widescreen or a television format project. The soundtracks can then be added, either from an external drive or downloaded from a network site. Large studios create a network site for an entire movie. This way the individual storyartist, after completing his or her portion of the film, can simply add it into the network file, or as we used to say 'cut it into the reel'.

3D Storyboarding—Pre-Visualization

This is a process known since 1992 as 'pre-visualization' or 'pre-vis'. A virtual set is constructed in the computer, and the characters placed in them as maquettes, often just simple graphic symbols without color. When the various cuts are considered, the storyartist not only has to take into consideration the camera angle, but also the camera lenses to be used and the light sources in the scene.

One single action of the actors could be restaged again and again from any angle in 360 degrees, with a myriad of possibilities for active camera moves. This all takes advantage of the in-the-round nature of 3D character animation.

Many times the storyartist begins with a rough traditional storyboard, then creates the pre-visual set with characters. At this time the director, and in the case of live action the cinematographer and lighting supervisor, would be invited to have their input.

In some big budget 3D films this process is done in the layout stage of production. This process was very useful when used with live-actor-based systems like motion capture or performance capture. The director films the action using several cameras, and all that data becomes the basis for staging the scene afterwards. Sometimes the camera position is the only thing captured, and it's position is computed in real time so that a live view of the 3D scene can be displayed through it's viewfinder. This allows the cameraperson to film a synthetic action as if it were a real event. This technique was used to support the 'documentary' hand-held feel in the Sony film *Surf's Up*, or the sweeping camera truck out as the Steward of Gondor aflame leapt to his death in *The Return of the King*.

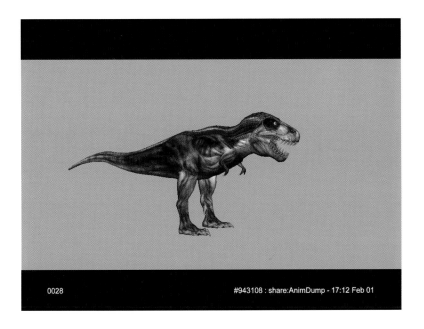

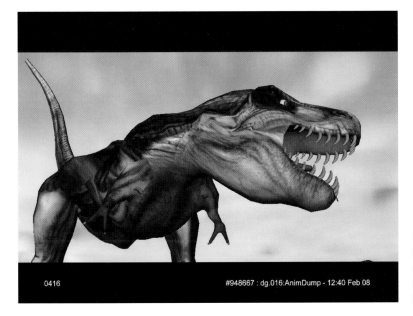

FIGURE 5 Pre-Viz set-up of dinosaur, showing how the camera can be moved in and around the same 3D artwork of the character. Courtesy of Rhythm & Hues Studios.

Additional Storyboard Effects

In the past, storyboards could be roughly drawn and simple enough to get the idea across quickly. Few outside of the production crew would see it, and they all understood its meaning to the final film. The exceptions were storyboards for commercial projects, which required a high degree of polish since some of the clients may have trouble imagining the finished product. But today many producers and backers of film are new to the field, so you have a better chance of getting your project approved by creating a look as close to the final film as is possible. Storyartists now routinely add temporary music and sound effects to their soundtracks and camera moves that in the past would only be suggested by red boxes and directional arrows.

Because of easy-to-use effects programs for your personal computer, many storyartists enhance their completed reels with additional tricks, done using software such as Adobe After Effects.

Programs such as these enable the storyartist to move a character through a scene like a simple cut-out. You can replace characters in a heavily detailed background without having to redraw that background over and over. You can add effects like real-looking smoke and flash-frames. You can also add motion blurs and fade through poses to approximate motion. Also, you can achieve a credible sense of depth by digitally breaking your composition into foreground, middle ground and background, and changing both field and focus in between them.

In the 1930s the Walt Disney Studio created a huge complex apparatus called the 'multiplane camera' to create the same effect that you can now easily create on your computer. All these effects are usually added in after the reels' timing is locked, because they require a lot of computer memory and work to redo.

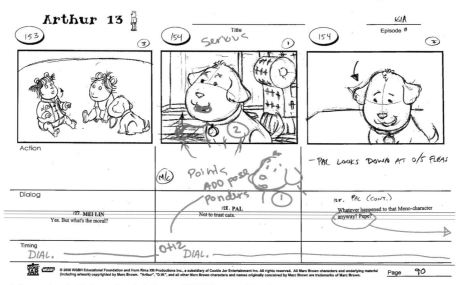

FIGURE 6 *Arthur* storyboard with director Greg Bailey's notes. (WGBH Educational Foundation/Cookie Jar Entertainment, underlying ©/™ in Arthur: Marc Brown.)

Responsibility of the Director

The director is responsible for decisions regarding the overall pacing and planning of the whole story or a particular sequence of it. This can involve sequences of several minutes' duration or of only a few seconds. The director must also decide how these sequences should be organized into scenes.

How long should each scene be? What should be the pace of the action in order to hold the interest of the audience? How can ideas in the story best be put over to the audience? These are the problems the director must solve. Going down to yet shorter periods of time, to individual actions, the responsibility is shared between the director and the animator. But the director still has overall control.

The animator should, however, add some ideas of their own as to how the character's performance can be achieved—just as an actor would in live action. The smallest units—individual drawings and frames—are almost entirely the animator's province, and this is where their particular skill lies. How does a ball bounce? How does a character react in surprise, or snap his fingers? These are problems the animator must solve by their feeling for and knowledge of the subject.

An animated film usually takes a long time to produce. During this period, it is essential that the director should keep a constant check on how the production is progressing and how closely the original timing and concept have been followed.

Most animated films are made to a predetermined length. A TV commercial must be an exact number of frames and a longer film will probably have to fit between fairly narrow limits. One of the director's problems is to fit the action to the time available.

First divide the story into sections or sequences of convenient lengths. Run through each section mentally as many times as necessary to absorb all the important story points. Then run through each section again, timing it mentally with a stopwatch. Add up all the timings to give an overall total. This is sure to be more or less wide of the mark. If it is fairly close, see whether a sequence can be adjusted to bring the total about right. If it is *much* too short, more business must be invented to fill the time available. If it is *much* too long, maybe a whole sequence must be omitted.

The Basic Unit of Time in Animation

The basis of timing in animation is the fixed projection speed of 24 frames per second (fps) for film and video. While other projection speeds have been used in the past, the standard projection rate for film of all formats—16 mm, 35 mm and 70 mm remains 24 fps. On television and video this becomes 25 fps (PAL) or 30 fps (NTSC and some computer programs), but the difference is usually imperceptible.

The thing to remember is that if an action on the screen takes one second it covers 24 frames of film, and if it takes half a second it covers 12 frames, and so on.

For single frame animation, where one drawing is done for each frame, a second of action needs 24 drawings. If the same action is animated on double frames, where each drawing is photographed twice in succession, 12 drawings

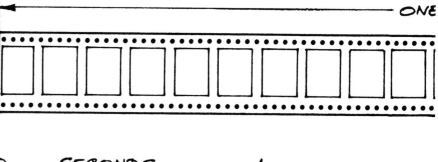

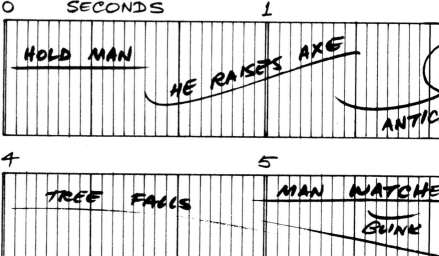

FIGURE 7 24 frames of film go through the projector every second (25 on television). This fixed number of frames provides the basis on which all actions are planned and timed by the director.

are necessary but the number of frames, and hence the speed of the action, would be the same in both cases. If creating animation to be matched against live action characters or settings, then the timing needs to be single frame. If you attempt to match exposures of two frames or longer to live action, the final composite scene will exhibit a noticeable skip or strobe in the motion.

Whatever the mood or pace of the action that appears on the screen, whether it be a frantic chase or a romantic love scene, all timing calculations must be based on the fact that the projector continues to hammer away at its constant projection rate. That is—24 fps for film and either 25 fps or 30 fps for television and video depending on format. The unit of time within which an animator works is, therefore, {1/24 }sec, {1/25 }sec or {1/30 }sec and an important part of the skill, which the animator has to learn, is what this specific timing 'feels' like on screen. With practice the animator also learns what multiples of this unit look like—3 frames, 8 frames, 12 frames, and so on.

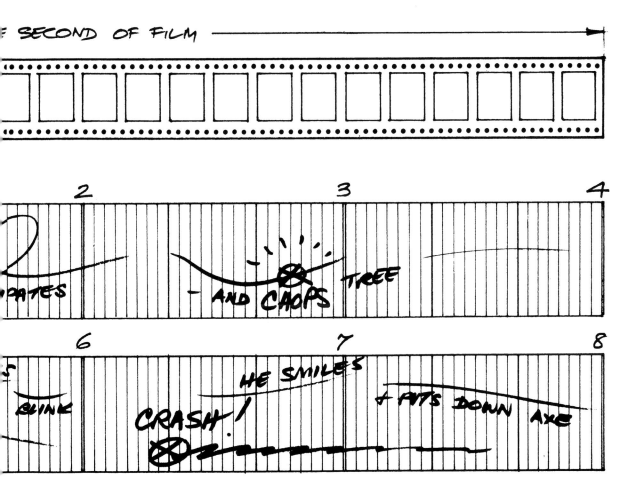

Timing for Television vs. Timing for Feature Films

A director must be aware of the differences in the format they are working in. The demands of a big budget theatrical, or full-length project, differ from a television show, game or web animation, which must be done with an economy of resources.

Whether it is done by computer, traditional or other mediums like claymation or puppets, quality feature animation is expensive. No expense can be spared if the finished film is expected to compete at the box office with the big live action Hollywood blockbusters. When audiences go to the theatre they expect ever-increasing cinematic experiences for their money. They are impressed with the technique for a moment, but then they expect a good story well told and visuals striking enough to merit not waiting to download it and watching it at home.

Animation for television, the web or other smaller media presents a different series of challenges. The limits of budget and time constraints on producing hours of programming necessitate a rethinking of your creative strategies. So to keep the limited-animated projects lively, the plots are usually carried along by means of dialog. Emphasis on dialog and sound over physical actions can save money. If the design of your show is more graphic and simple, the audience is more tolerant of the simplicity of its movement, rather than a very realistic design that does not seem to move enough.

FIGURE 8 *Arthur* storyboard with director Greg Bailey's slugs. (WGBH Educational Foundation/Cookie Jar Entertainment, underlying ©/™ in Arthur: Marc Brown.)

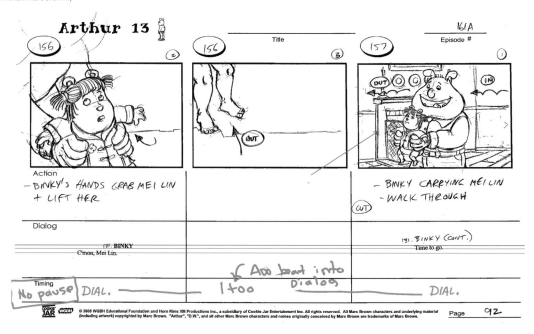

Slugging

In the production of a television series, keeping the shows at the required running length is vital to staying on budget and avoiding costly production overruns. If the contract with a television station is to deliver 12 episodes of 24 minutes 40 seconds each with station breaks, you cannot give them 26 or 28 minutes with excuses. And it means money was wasted to animate and color scenes that were destined to be edited and thrown away to keep the show at length.

To keep their shows at the required length, directors or a story editor will pre-time a script outloud with a stopwatch. Almost like a table-read in the theatre. Also, many animation directors resort to a system called 'slugging'.

While the storyboards are being done, the actors record their voices 'railroad-style'. This means they do their takes in order, not allowing for any acting pauses or extra time for pantomime. On a series that is extra concerned with conserving their resources, the actors may do two or more complete episodes in one session.

While the soundtrack is being edited from the collection of individual 'takes', the director goes through the storyboard with a stopwatch and 'slugs' the board, which means noting the amount of time for the pauses in between lines of dialog. This way the amount of time needed for actions not using dialog can be roughly anticipated. This may be an action sequence like a fight, a 'take' or reaction of another character, a setting transition, a comedy pantomime or an establishing master shot of a new setting.

Adding the total amount of slugs and dialog lengths together gives the director an idea of the total length of the show before any animator has begun to draw. Once the slugs are added to the edited soundtrack assembly, some further trimming is done to ensure the show stays at its required length.

Some allowance should be given for the animator to expand the length of their scenes to create an inspired bit or performance. In this case, time will have to be lost somewhere else in the reel, but that can be done in the final edit. It is the director's decision.

Another school of thought in TV production is to run the recording session in a block with all the voice actors as though it were a final performance. If this dialog is well recorded for maximum dramatic effect, lengths of pauses between phrases cannot be changed (except within very narrow limits) without destroying that effect. In this case, the overall timing of long sections of the film is governed entirely by the dialog. (There could be, however, considerable flexibility for more detailed timing within this fixed overall length.)

In this approach, the director has room to manoeuvre sections. So, if the total timing for all the recorded dialog is subtracted from the required length for the whole film, this gives the amount of time that is available without dialog. This can then be split up and distributed throughout the film to give the best effect. The drawbacks are the difficulty in corralling all the voice actors to record in studio all at a set time, and making broad guesses at the microphone as to the length of some future bit of physical action.

PROD. NO. C.854 NAME PART A.						CLIENT			
REMARKS	ANIM. NAME	SC. NO.	DESCRIPTION	FTGE.	ANIM.	C.U.	B.G.		
	ED	1	F/I. L.S. INT. THEATRE —TRACK IN	7-0	■		1		
	ED	2	C.U. SAM ANNOUNCES J.S — PAN TO ROBOT	7-0	■		2		
STOCK ?	ED	3	C.U. ROBOT DOES ROUTINE (RIPPLE MIX)	13-8	■	□	3		
	DS	4	M.S. MIKE & MARLON IN JUNK-FILLED WORKSHOP.	8-8	■		4		
	DS	5	C.U. MARLON WITH WOODEN MALLET.	4-4	■		5		
	DS	6	C.U. MIKE - PUZZLED	3-4	■	□	5		
S.A.5	DS	7	C.U. MARLON	2-0	◣		5		
	DS	8	M.C.U. MIKE & ROBOT -HE POINTS - "WHAT IS THAT?"	3-8	◹		5		
PAN	DS	9	M.C.U. MARLON & ROBOT —TRACK IN & PAN ALONG ROBOT.	14-0	◹		5 OL9		
S.A.5	DS	10	C.U. MARLON	3-0	◣		5		
S.A.6	PJ	11	C.U. MICHAEL FEIGNS INTEREST	9-8			5		
S.A.5	DS	12	C.U. MARLON	5-8	◤		5		
S.A.6	PJ	13	C.U. MIKE — NOT INTERESTED	4-0			5		
	PJ	14	C.U. MIKE'S POCKET. - MICE POP UP - AND DOWN	8-0			14		
S.A.6	PJ	15	MIKE LOOKS UP WITH INTEREST	3-0			5		
	PJ	16	C.U. ROBOT. - MIKE'S HAND IN & POINTS	8-0			5 OL9		
S.A.6	PJ	17	C.U. MICHAEL. - REALLY DELIGHTED.	6-8			5		
S.A.5	DS	18	C.U. MARLON DOORBELL EFX. (OFF)	3-8	◤		5		
S.A.6	PJ	19	C.U. MIKE TURNS & GOES OUT.	5-8			5		
	ED	20	EXT. FRONT DOOR. - C.U. MIKE POPS OUT - TRACK TO INCLUDE SAM	11-0	◹		20		
	ED	21	C.U. SAM RAISES HAT — LEANS FORWARD	5-8	◹		20		

FIGURE 9 Part of a production breakdown chart. After the director has decided on the timing, scene continuity and so on, this information is transferred to a chart showing scene numbers, footages, background numbers, etc. As scenes are passed out and completed, boxes are shaded in on this chart so that the state of production can be seen at a glance.

Bar Sheets

From the advent of sound pictures until the Digital Revolution, the practice was that after the soundtrack was assembled with the called-for pauses or slugs timed accordingly to the story reel, the director fine-tuned his timing instructions on bar sheets. At Walt Disney these were also called 'the greys'. The director decides on scene continuity, the exact length of each scene and what action takes place within it. They also plan the pace of the storytelling and decide where tracks, pans, mixes, etc. are needed to put the story over in the best possible way.

At the beginning of the film the director knows what is about to happen but the audience does not. The timing at the start of a film is, therefore, probably rather slow until the audience has been introduced to the location, the characters and the mood of the film. Once this has been done, the pace may build up to the climax if it is a short film. If it is a longer film, it may build up to a series of climaxes.

The bar sheets were useful in that having defined the complete continuity of the film, with scene lengths and other information, they could also serve as the basic reference for the composer, and for the editor when the final film was assembled.

Bar sheets are not used as much as they were before computers, but some studios still swear to their dependability.

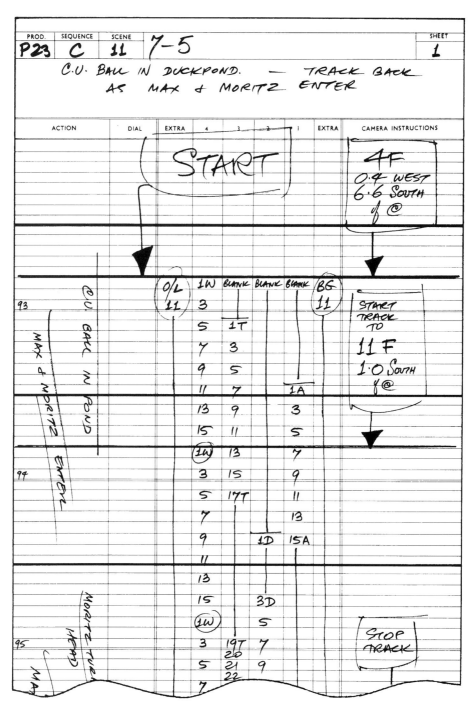

FIGURE 10 Part of a completed exposure sheet for an individual scene. Each horizontal division represents one frame of film. The director's timing is in the left-hand column and the camera instructions are on the right. The animator has written the numbers of their drawings in the middle six columns.

Timing for Traditional Animation: Exposure Charts or Exposure Sheets

When the director has completed his/her timing notes, either on the reels or on bar sheets, the information is split up scene-by-scene ready for distribution to the animators.

The timing is transferred to printed dope sheets (UK), which are known as 'exposure sheets' or 'X sheets' in the USA. Some studios use charts with units of 4 seconds (96 frames) on each sheet. Others, who primarily work in television where the speed of projection is 25 frames per second, use sheets in 100 frame units, which provide 4 seconds of running time for television.

Animation timing is usually indicated by the director in the left column of exposure charts so that the animator can work out the number of drawings required to complete each action in the other columns. This information is useful to all members of an animation unit: the animators, their assistants and the cameraman. Alongside the production of animation, the exposure charts are filled in according to the levels of cells or celluloids to be photographed, and eventually serve as guides for photography.

The left column, or director's notes, is where many directors can affect their animator's performance most directly. Legendary directors of the past like Chuck Jones used this place to put detailed instructions, complete with small sketches and diagrams. In the famous *Simpsons* TV series, the directors would have many pose drawings created and then time them precisely to maintain a continuity of performance.

People have their own individual shorthand, but generally a horizontal line means a hold, a curve means an action of some sort, a loop means the anticipation to an action, a wavy line means a repeat cycle, and so on. If an action must take place on a certain frame, this is marked with a cross on the required frame. The action is also written out verbally with stage directions, repeat animation instructions and other relevant information. Some directors would even draw simple poses in the appropriate spaces to more clearly explain what they needed.

Timing on X sheets is an extremely skilled operation. The director needs a great deal of experience to time out a film mentally before any drawing is done. When he or she commits their ideas to paper on the sheets, they are telling the story in terms of film, i.e. cutting, timing and pace (movement). The director has already animated the film in their mind.

They must run forwards and backward through the story many times in their mind, relating the different parts of the story to one another in terms of dramatic flow. At the same time, they must be trying continually to judge what the effect will be on an audience who come fresh to it and who see the film through once only.

Timing for an Overseas Production

With today's global productions it is not often that a director will have access to their staff under one roof. Many times they will be directing crews on the other side of the world, who may not speak their language. In this case, the director needs to be even more exact in the details of their notes on the dope/exposure sheets. Cultural differences and differing theatrical traditions must be taken into account when explaining their wishes. A simple gag like the magician pulling a rabbit out of a hat may be totally unknown to the artists being used. So the director's notes must be painstakingly specific and clear: 'Magician's arm anticipates back 8 frames, thrusts into hat 4 frames, hold 12 frames, pull out rabbit 6 frames, hold and react 72 frames, etc.' and in any explanations care must be taken to avoid confusing local slang. Once when I said a character was feeling blue—meaning petit melancholia—the scene came back with the character painted with blue skin! Another time the storyartist left the note that the Superhero took off like a rocket, and the overseas artists literally morphed his body shape into a rocket before blasting off.

The director timing for overseas production must be cognizant of the fact that many of the artists they will be using are being paid for the quantity of their output more than the quality. So they must not take for granted that the animators will add that extra sense of playful performance in their assignment. There will be exceptions, but most are only expected to move the characters from Point A to Point B, as indicated in the layouts and exposure sheets. If the director wants more than that they must take the initiative to add additional poses and specific notes to add to the performance, and maintain close communication with the overseas supervisors.

Timing for a 2D Digital Production

In many 2D animation programs the notes on paper exposure/dope sheets have been replaced by digital levels displayed upon the computer screen. The director times out their cuts using the story reel, almost as an editor would do traditionally. Then they create an extra level on which to write and draw their notes digitally using a stylus and tablet. The director may write on each frame, or create rough sketches for the animator to use as guideposts. All of this has the benefit of immediate and repeated playback.

Timing for a 3D Digital Production

When directing artists using a 3D program, in many cases there are no exposure sheets to work from, or additional columns on the reel. The director must get their wishes to the animator using storyreels (animatics) with many specific poses, then a detailed face-to-face conference to explain all they want done. In this face-to-face meeting, the director would give the animators quick sketches or diagrams to better illustrate his or her points. Director Brad Bird would have the reel projected upon a whiteboard for his staff and explain his wishes by drawing with a dry-erase marker right on the held frames.

When directing for a 3D production to be done overseas, the director can be filmed doing the lecture, explaining his or her wishes, complete with illustrations. The overseas studio then sees this tape. Or arrangements can be made for a virtual teleconference.

The animator takes the character with its built-in controls, called the 'rig', and using the control levers creates the major poses, called 'key frames'. After the inbetweens and blurs are added, the speeds of the movement can be sped up or slowed down by moving the spacing bar or spline. The director can later correct the animator's performance by also moving this bar.

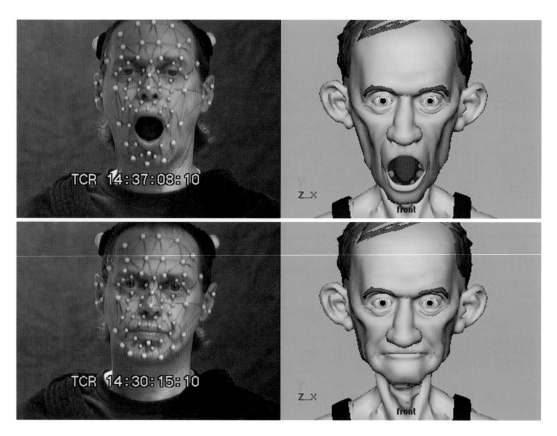

FIGURE 11 Actor Steve Buscemi with motion-capture sensor rig and rough character pose for the film *Monster House*. (MONSTER HOUSE © 2006 Columbia Pictures Industries, Inc. and GH One LLC. All Rights Reserved. Courtesy of Columbia Pictures.)

Timing for an Actor-Based Program (Performance or Motion Capture)

A popular animation technique that has grown since the turn of the Millennium has been motion or performance capture. Here an actor is covered in special sensors that record their motions in the computer in real time. In recording the scene, the director can interact with the actor much like a live action director does. He or she can use a live action cinematographer to set the camera angles and camera moves after the performance is done. It promises a potential way to create realistic-looking human animation more easily.

The filmmaker must be cautioned that the acting avatar's movements are not the final performance. After the performance is recorded in the computer, the animator must get in and flesh out the key frames of the animation. He or she moves frames closer or further apart, and augments or 'pluses' poses to complete the animated performance. Like in the old technique of rotoscope, where the live actor's movement was traced over, the motion capture actor provides scale, staging and basic performance. But to be used to its greatest effect, the subtleties and nuances have to be gone over and enhanced by a key-frame animator.

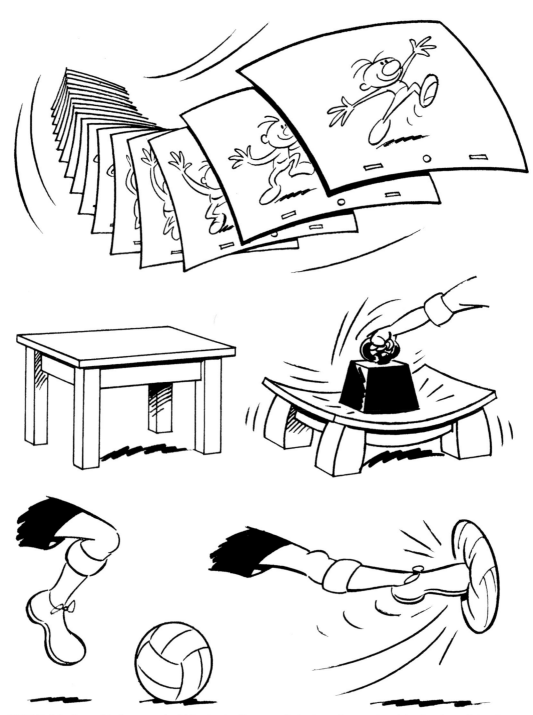

FIGURE 12 Animation consists of sequences of weightless drawings. The success of animation on the screen depends largely on how well these drawings give the impression of reacting in an exaggerated way when weight and forces are made to act upon them.

Animation and Properties of Matter

The basic question which an animator is continually asking themself, is: 'What will happen to this object when a force acts upon it?' And the success of their animation largely depends on how well this question is answered.

All objects in nature have their own weight, construction and degree of flexibility, and therefore each behaves in its own individual way when a force acts upon it. This behavior, a combination of position and timing, is the basis of animation. Animation consists of drawings, which have neither weight nor do they have any forces acting on them. In certain types of limited or abstract animation, the drawings can be treated as moving patterns. However, in order to give meaning to movement, the animator must consider Newton's laws of motion, which contain all the information necessary to move characters and objects around. There are many aspects of his theories which are important in this book. However, it is not necessary to know the laws of motion in their verbal form, but in the way which is familiar to everyone, i.e. by watching things move. For instance, everyone knows that things do not start moving suddenly from rest—even a cannonball has to accelerate to its maximum speed when fired. Nor do things suddenly stop dead—a car hitting a wall of concrete carries on moving after the first impact, during which time it folds itself rapidly up into a wreck.

It is not the exaggeration of the weight of the object which is at the centre of animation, but the exaggeration of the tendency of the weight—any weight—to move in a certain way.

The timing of a scene for animation has two aspects:

1. The timing of inanimate objects.
2. The timing of the movement of a living character.

With inanimate objects the problems are straightforward dynamics. 'How long does a door take to slam?' 'How quickly does a cloud drift across the sky?' 'How long does it take a steamroller, running out of control downhill, to go through a brick wall?'

With living characters the same kind of problems occur because a character is a piece of flesh which has to be moved around by the action of forces on it. In addition, however, time must be allowed for the mental operation of the character, if he is to come alive on the screen. He must appear to be thinking his way through his actions, making decisions and finally moving his body around under the influence of his own will-power and muscle.

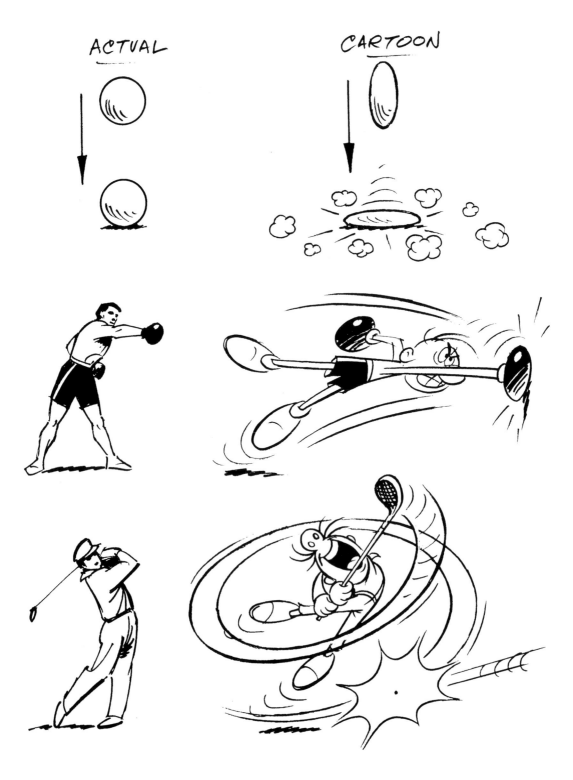

ACTUAL

CARTOON

Movement and Caricature

The movement of most everyday objects around us is caused by the effect of forces acting upon matter.

The movement of objects becomes so familiar to us that, subconsciously, these movements give us a great deal of information about the objects themselves and about the forces acting on them. This is true not only of inanimate objects, but also of living things—especially people.

The animator's job is to synthesize movements and to apply just the right amount of creative exaggeration to make the movement look natural within the cartoon medium.

Cartoon film is a medium of caricature. The character of each subject and the movement it expresses are exaggerated. The subjects can be considered as caricatured matter acted upon by caricatured forces.

Cartoon film can also be a dramatic medium. This particular quality can be achieved, among other means, by speeded up action and highly exaggerated timing. The difference between an action containing caricature, or humor or drama, may be very subtle. Eventually, with enough experience in animation timing, it becomes possible to emphasize the difference.

Caricatured matter has the same properties as natural matter, only more so. To understand how cartoon matter behaves it is necessary to look more closely into the way matter behaves naturally.

FIGURE 13 Cartoon is a medium of caricature—naturalistic action looks weak in animation. Look at what actually happens, simplify down to the essentials of the movement and exaggerate these to the extreme.

Cause and Effect

There is a train of cause and effect which runs through an object when it is acted upon by a force. This is the result of the transmission of the force through a more or less flexible medium (i.e. caricatured matter). This is one aspect of good movement in animation.

An animator must understand the mechanics of the natural movement of an object and then keep this knowledge in the back of their mind whilst concentrating on the real business of animation. This is the creation of mood and conveying the right feeling by the way an action is done.

Examples of cause and effect:

Figs A and B

A rope wrapped around *anything* and pulled tight has the tendency shown. How far the reaction goes depends on:

i The strength of the forces pulling the rope.
ii The flexibility or rigidity of the object being squeezed.

Exaggerate the tendency.

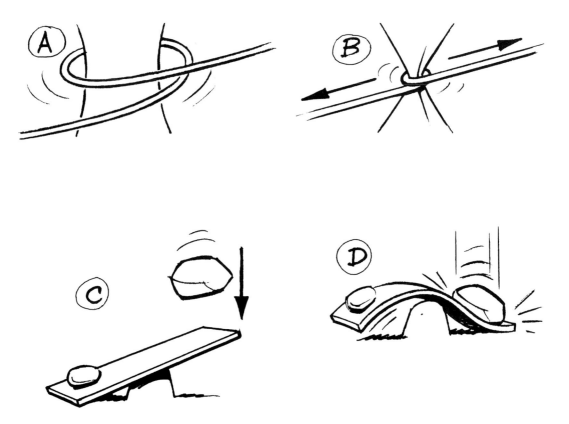

Figs C, D and E

On the seesaw, the end of the plank with the smaller stone tends to stay where it is to begin with because of its inertia, so bending plank **D**. A moment later it starts to accelerate and the plank springs back with the opposite curvature causing the stone to whizz out of the screen, **E**.

Figs F, G and H

The man is bending over to pick up something. His reaction when pricked is:

G A reflex jerk to remove his behind from the pin.

H A look of surprise or horror as he turns to see what is happening.

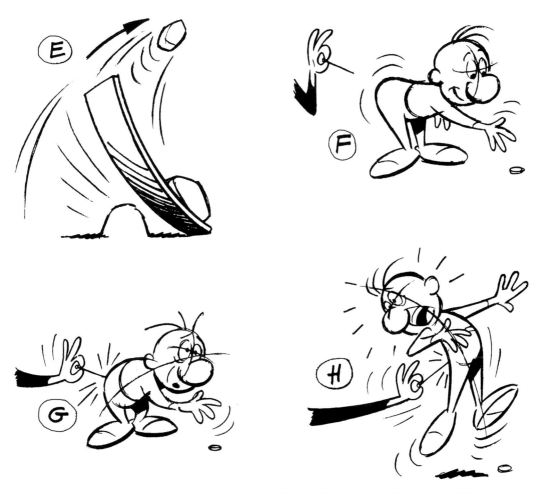

FIGURE 14 **A** A rope wrapped round something. **B** The ends of the rope are pulled tight. **C** A stone on one end of a seesaw. **D** and **E** A bigger stone drops onto the other end. **F** A man stoops to pick something up. **G** and **H** He reacts when pricked by a pin.

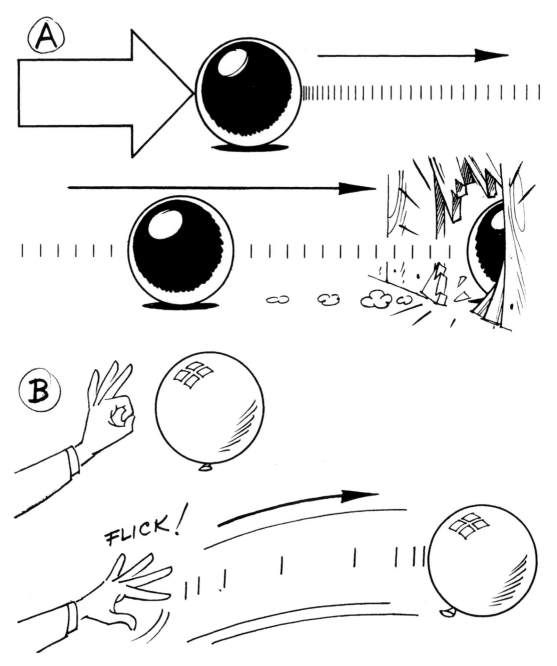

FIGURE 15 **A** A cannon ball needs a lot of force to start it moving. Once moving, it takes a lot of stopping. **B** A balloon needs only a small force to move it, but air resistance quickly brings it to rest. In both these examples a circle is being animated. The timing of its movements can make it look heavy or light on the screen.

Newton's Laws of Motion

Every object or character has weight and moves only when a force is applied to it. This is Newton's first law of motion. An object at rest tends to remain at rest until a force moves it, and once it is moving it tends to keep moving in a straight line until another force stops it.

The heavier an object is, or strictly speaking the greater its mass, the more force is required to change its motion. A heavy body has more inertia and more momentum than a light one.

A heavy object at rest, such as a cannonball, needs a lot of force to move it (Fig. A). When fired from a cannon, the force of the charge acts on the cannonball only whilst it is in the gun barrel. Since the force of the explosive charge is very large indeed, this is sufficient to accelerate the cannonball to a considerable speed. A smaller force acting for a short time, say a strong kick, may have no effect on the cannonball at all. In fact it is more likely to damage the kicker's toe. However, persistent force, even if not very strong, would gradually start the cannonball rolling and it would eventually be traveling fairly quickly.

Once the cannonball is moving, it tends to keep moving at the same speed and requires some force to stop it. If it meets an obstacle it may, depending on its speed, crash straight through it. If it is rolling on a rough surface it comes to rest fairly soon, but if rolling on a smooth flat surface, friction takes quite a long time to bring it to rest.

When dealing with very heavy objects, therefore, the director must allow plenty of time to start, stop or change their movements, in order to make their weight look convincing. The animator, for their part, must see that plenty of force is applied to the cannonball to make it start, stop or change direction.

Light objects have much less resistance to change of movement and so behave very differently when forces act on them. A toy balloon (Fig. B) needs much less time to start it moving. The flick of a finger is enough to make it accelerate quickly away. When moving, it has little momentum and the friction of the air quickly slows it up, so it does not travel very far.

The way an object behaves on the screen, and the effect of weight that it gives, depends entirely on the spacing of the animation drawings and not on the drawing itself. It does not matter how beautifully drawn the cannonball is in the static sense—it does not look like a cannonball if it does not behave like one and the same applies to the balloon, and indeed to any other object or character.

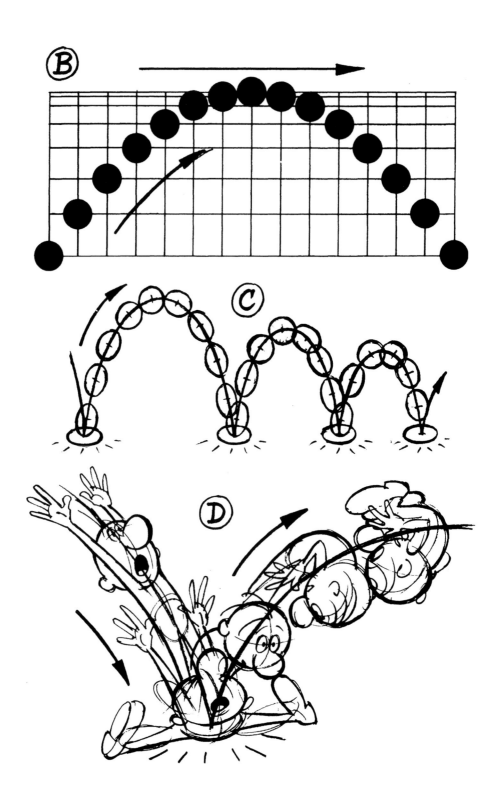

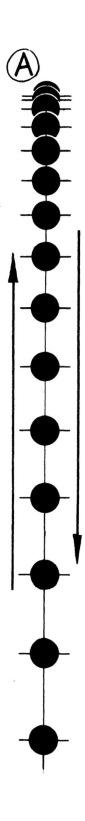

Objects Thrown Through the Air

If an object is thrown vertically upwards, its speed gradually diminishes to zero (Fig. A). It then starts to accelerate downwards again. The height to which it rises depends on the speed at which it is thrown, but the rate of deceleration is the exact opposite of the acceleration as worked out on page 34. In fact the same scale can be used for both acceleration and deceleration.

If a ball is thrown upwards at an angle, then its movement has two components: vertical and horizontal. Vertical speed diminishes to zero and increases again as it falls, whilst at the same time its forward movement remains fairly constant. This means the ball moves along a parabola (Fig. B).

If a rubber ball is thrown down on a hard smooth surface, it moves with a series of bounces. The curve between one bounce and the next is again a parabola. The parabolas diminish in height each time, as some energy is lost by the ball on each bounce (Fig. C).

If possible, drawings around the actual bounce should be spaced as in Fig. C. The drawing after the squash should overlap the squash drawing slightly, as the ball accelerates to its maximum speed again. On the remainder of each parabola, the drawings tend to bunch together at the top and spread apart at the bottom of the curve, as in Fig. B.

If, when the ball is timed out at the required speed, there is a large gap between one drawing and the next, compared with the diameter of the ball, then it is a good idea to stretch the circle slightly into an ellipse in the direction in which the ball is traveling. This, possibly with speed lines added (see page 112), helps to lead the eye from one drawing to the next and smooth out the movement. This should not be overdone, however, particularly at slow speeds, as it may give a rather floppy effect to the ball.

FIGURE 16 **A** The speed of a ball, rising vertically under the influence of gravity, gradually diminishes to zero. The same spacing of drawings can be used for its acceleration as it falls back to earth. **B** If the ball is thrown upwards at an angle, it travels in a parabola. **C** A rubber ball bouncing on a hard surface proceeds in a series of diminishing parabolas, as energy is lost on each bounce. **D** A cartoon character bounces in much the same way as a ball.

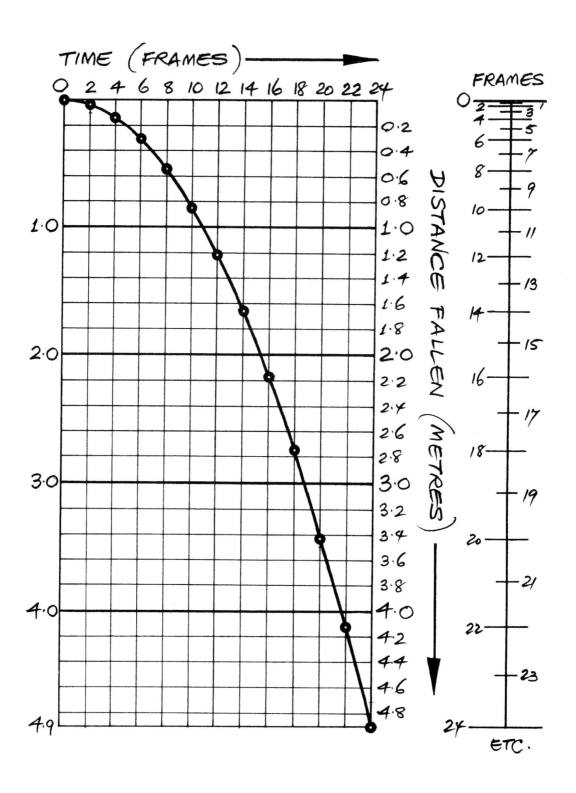

TIME (FRAMES) ⟶

0 2 4 6 8 10 12 14 16 18 20 22 24

DISTANCE FALLEN (METRES)

1·0

2·0

3·0

4·0

4·9

0·2
0·4
0·6
0·8
1·0
1·2
1·4
1·6
1·8
2·0
2·2
2·4
2·6
2·8
3·0
3·2
3·4
3·6
3·8
4·0
4·2
4·4
4·6
4·8

FRAMES

0
2
3
4
5
6
7
8
9
10
11
12
13
14
15
16
17
18
19
20
21
22
23
24

ETC.

Timing of Inanimate Objects

An inanimate object that has weight and is being acted upon by known forces moves in a predictable way. As a simple example, consider an object falling from rest under the influence of gravity. Disregarding air resistance, all objects fall with the same acceleration, which is about 9.8 meters per second. In practice, of course, the buoyancy of the air makes a leaf behave very differently from a lump of lead when dropped. However, assuming that an object is dropped which has an average weight, then the distance it falls in time, 't', with an acceleration, 'f', is given by the formula:

$$\text{Distance} = \tfrac{1}{2}ft^2$$
$$= 4.9t^2 \text{ meters}$$

By substituting some numerical values for 't', distances fallen are as follows:

after $\tfrac{1}{8}$ second—0.08 meters

$\tfrac{1}{4}$ second—0.3 meters

$\tfrac{1}{2}$ second—1.2 meters

1 second—4.9 meters, etc.

A graph with the time in frames plotted against the distance fallen gives a parabola (see Figure 17). At a projection speed of 24 frames per second, the object falls as follows:

0.08 meters after 3 frames
0.3 meters after 6 frames
1.2 meters after 12 frames
4.9 meters after 24 frames, etc.

FIGURE 17 Speed chart of an average object falling under gravity. The air resistance affecting the fall of a feather, or a heavy brick, must be taken into account. Disregarding air resistance, an object falling from rest accelerates at a fixed rate. If the distance fallen is plotted against the time taken, it gives a parabola. The vertical scale on the right shows the distance fallen in a given number of frames. Starting from rest, whatever distance an object falls in a given time interval, it travels four times as far in twice that interval. For example, it travels four times as far in 18 frames as it does in nine.

In animation it is not usually necessary to work out a movement like this mathematically. It is all right if it *looks* right, and it looks right if the movement it's based on is what actually happens in nature—simplified and exaggerated, if necessary, for dramatic effect.

35

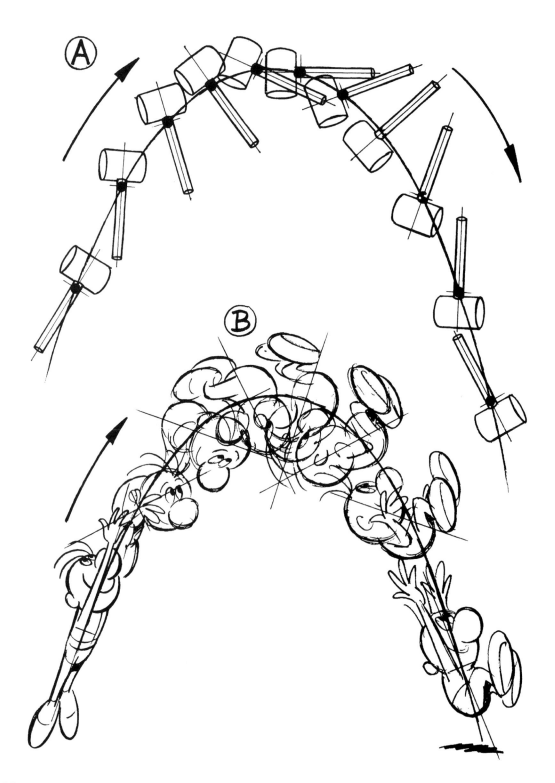

Rotating Objects

To say that a bouncing or thrown ball travels along a parabola really means that its center of gravity does so. The mass of any body acts as though concentrated at its center of gravity.

Irregular Inanimate Objects

If an irregular shaped object is falling or being thrown through the air, the movement of its center of gravity along a parabola can be timed. As most objects have a tendency to rotate when flying through the air, the object is then drawn pivoting by a fixed amount about the successive positions of the center of gravity along the parabola. For example, with a heavy hammer most of the weight is in the metal head and the center of gravity is therefore close to this end. This would produce successive positions of the hammer as in the illustration (Fig. A). The shape of the hammer and the speed and direction of rotation might vary but the principle of movement remains the same.

In animation, if the speed of an object is sufficient, changes in perspective as the object rotates are not apparent. It is usually enough to have one drawing of the object with the position of the center of gravity marked on it. This can then be placed with the center of gravity over the required point on the parabola and traced off in this position. The center of gravity is then placed over the next successive point on the parabola, turned through the required angle, and traced off on this position, and so on.

Animate Objects—Characters

In an object whose shape is variable, such as a man, the position of the center of gravity also changes. If the man falls or jumps through the air, his center of gravity also travels along a parabola (Fig. B), even though the shape of his body changes and he may rotate in much the same way as an inanimate object.

FIGURE 18 **A** All objects moving in free flight under gravity move in parabolas. A thrown hammer spinning through the air rotates round its center of gravity, but the center of gravity itself travels on a parabola (unless it goes into orbit, when it travels on an ellipse). **B** The center of gravity of a man travels on a parabola when he jumps or dives through the air.

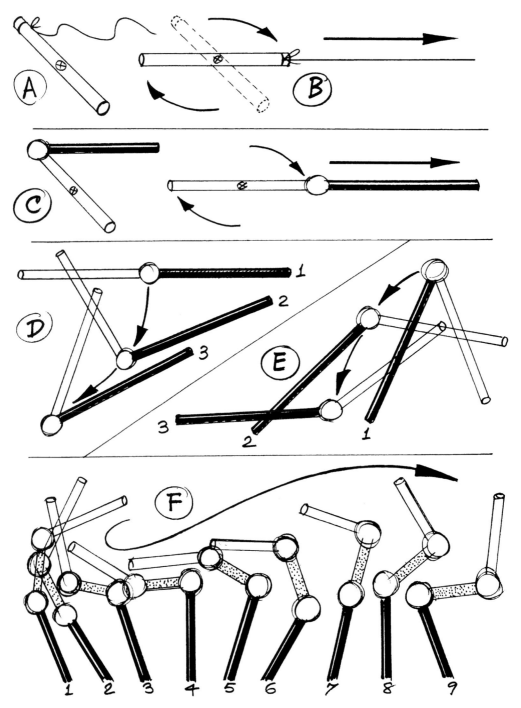

FIGURE 19 The action of a force through a flexible joint. **A** to **E** The movement of a stick when a force is applied to it through a flexible joint. The white stick moves as a result of the movement of the black stick. **F** The movement of three sticks flexibly joined together (drawings spread out side by side for clarity).

Force Transmitted Through a Flexible Joint

Imagine a length of wood with string fastened to one end of it, lying on a fairly smooth surface (Fig. A). Pull the stick towards the right, by means of the string, from a direction roughly at right angles to the length of the stick. The first thing that happens is that the string pulls taut. Obviously the stick is not going to move whilst the string is slack. The weight of the stick acts as though concentrated at its center of gravity, and so the stick as a whole does not start to move in the direction of the pull until its center of gravity is in line with the string. So the stick rotates until the axis of the stick and the string are in line, and then moves off (Fig. B).

If instead of the string another stick is used, flexibly jointed to the first one (Fig. C), then something very similar to Fig. B occurs if the second stick is moved to the right. If the second stick (shown black) is now moved around as in Figs D and E, then the white stick moves more or less in the way shown, provided the joint is quite flexible. If the white stick is pushed around and is the prime mover, then the black stick behaves in a similar way to the white one in Figs D and E.

The main characteristic of these movements in animation is that when the primary stick accelerates or changes direction, the successive drawings of the secondary stick overlap each other as the stick rotates.

If three sticks are flexibly jointed together, and the lower stick is rocked to and fro fairly quickly, so that the effect of the momentum of the other two sticks becomes noticeable, the combined movement is similar to Fig. F.

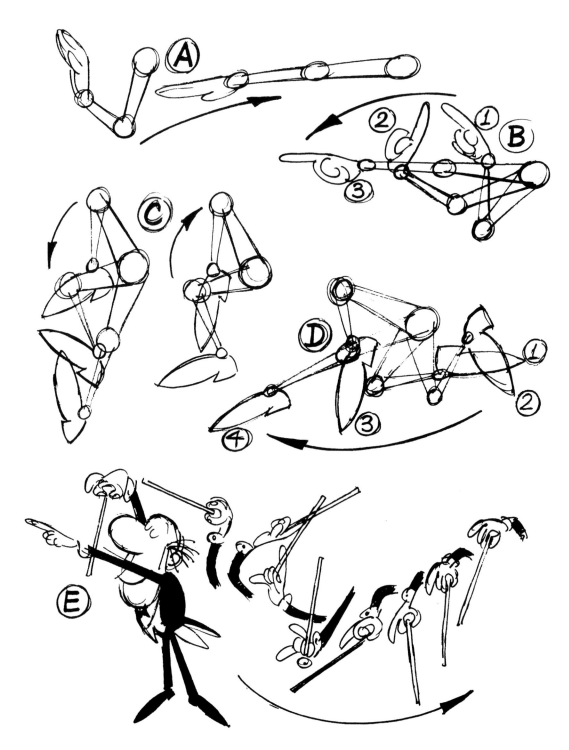

Force Transmitted Through Jointed Limbs

In character animation, force is very frequently transmitted by means of more or less flexible joints.

An animal or man can be thought of as a series of fairly loosely connected sections. A leg consists of the thighbone connected to a ball and socket joint at the hip; the lower leg, with a hinge joint at the knee; and the foot which is fairly flexibly jointed at the ankle. The arm is jointed from the shoulder in a similar way. So if a subject's shoulders are jerked backward, his hands tend to follow only after his arms are pulled into line with the centers of gravity of his hands (Fig. A).

This is not strictly true, of course, with live characters because if the movement is slow enough, the muscles have time to contract and stop the arms straightening completely. Nevertheless the tendency is there, and it is these tendencies which the animator picks on and exaggerates. The faster the action, the greater the exaggeration.

Hands and feet move in the same way as the white rods on page 38. They tend to rotate on their centers of gravity when the direction of movement changes. In Fig. B, with a flexible wrist, the hand tends to trail backward in the middle of a forward movement and in Fig. C the foot tends to trail in the direction it is coming from when the leg is lowered or raised, and in Fig. D during a kick.

An object held loosely in the fingers behaves in a similar way when the hand is moved about (Fig. E).

FIGURE 20 How flexible joints are manipulated affects the animation of humans as well as animals. **A** This is the equivalent in human terms of Fig. C on page 40. **B** Note flexibility of wrist. **C** and **D** Note flexibility of ankle as foot is lowered and raised, and during a kick. **E** From the Hoffnung *Symphony Orchestra* showing movement of flexible arm and loosely held baton.

Spacing of Drawings—General Remarks

When any object in nature moves from a rest point X and stops at a point Y, it has a tendency, owing to the properties of matter, to accelerate to a maximum speed in the middle of the movement and then slow down to a stop (Fig. A). Obviously there are an infinite number of variations in detail, but this is the general tendency. A piston going to and fro moves more slowly at the ends of its movement, and so in animation the drawings are closer together at the ends of the movement than in the middle. This kind of movement is called 'simple harmonic motion', and can be arrived at by projecting equidistant points on the circumference of a circle onto a straight line (Fig. B).

In animation it is sometimes difficult to graduate the space between drawings in this way and so usually an approximation is made by halving, rehalving and halving again the distance to be traveled, according to the time available. In some cases distances are split for convenience into thirds, or even quarters, although other proportions are usually impracticable (Fig. C).

FIGURE 21 **A** An object moving from one point to another accelerates from rest to a maximum speed and then decelerates to a stop. **B** The projection of the positions of a point moving round a circle on to a straight line gives the positions of a point moving up and down the line, with simple harmonic motion.

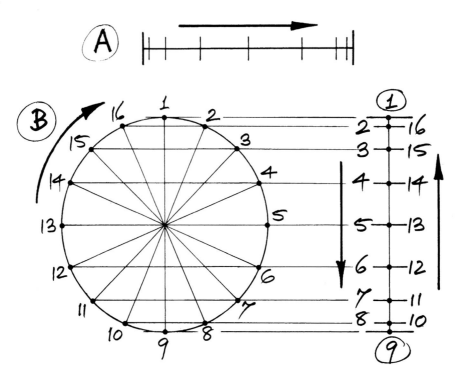

A human figure moving to and fro, sawing for example, moves in a similar way to a piston. The body weight moves forward, slows down, changes direction and starts to move backward, slows down, changes direction, starts to move forward, and so on. The general weight of the body moves forward and backward, and the drawings are therefore spaced in the same way as those for a piston. The spacing of the drawings of the arm and saw are different from that of the weight of the body (see page 36) because the action of sawing requires manipulation of weight and muscle-power.

C Methods of inbetweening which are used in various combinations depending on the speed of the movement. D A man sawing slows into and out of the two extremes of the movement (see also page 36).

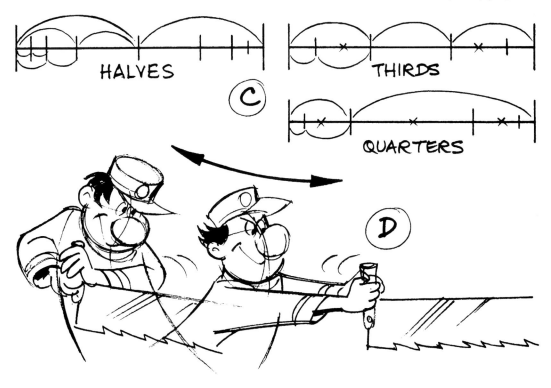

HALVES

C

THIRDS

QUARTERS

D

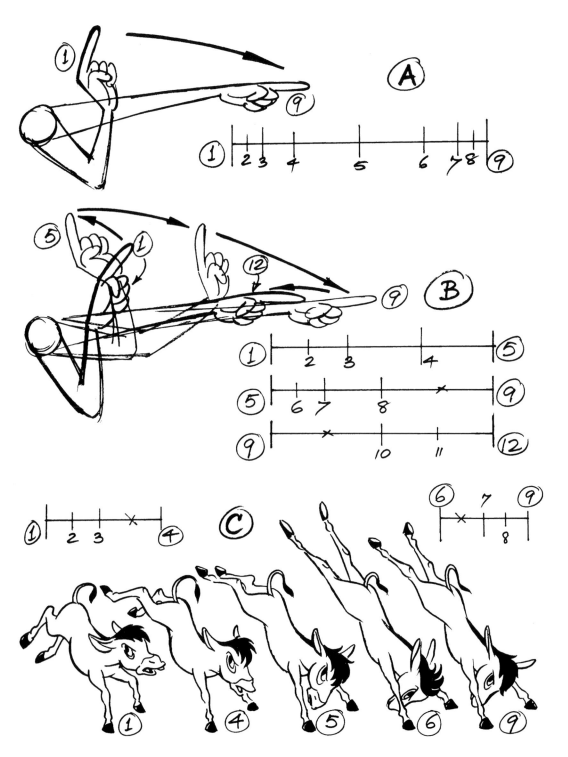

Spacing of Drawings

As explained above, the basis of timing is the established film speed of 24 frames per second. If, therefore, something moves from A to B in six frames, the drawings required to do this are spaced twice as far apart as they would be if the object moved from A to B in 12 frames—assuming single frame animation, or 'ones', is used in both cases.

Therefore, for an animator, the timing of an action is the same as deciding the number and spacing of the drawings or key poses needed to make up the action.

How many drawings are needed, for example, to make a character point his finger off screen? It is necessary to know a number of things to answer this. Is the character slow or quick in his reactions? Is he pointing, for example, to a distant view or is he pointing to warn somebody that a car is about to run him down? Is it a full arm movement or a more restricted finger movement?

If it is a fairly gentle movement, the action might take about 16 frames to complete, which on double frame animation, or 'twos', would be eight drawings. If the arm is at rest at the beginning and end of the movement, then the drawings are spaced more closely at the beginning and end. This gives the impression that the arm is a fairly weighty object accelerating from rest and decelerating again at the end of the movement.

FIGURE 22 **A** A simple arm movement, accelerating at the beginning and decelerating at the end. **B** A more violent point. Drawings 1–5 anticipate the movement, the hand shoots out too far on 6–9 and returns to the final position on 10–12. **C** A kicking donkey gives a more violent example of overshooting.

Timing a Slow Action

Occasionally it is necessary to animate movements which strain the medium to its limit, such as slow movement. In a lyrical mood, slow motion or a comedy situation this may be unavoidable. The closer drawings are to each other, the slower the movement appears. On the other hand, the wider the spacing between drawings, the quicker it looks on the screen. But there is a limit in both directions.

Closely spaced drawings tend to jitter if not drawn with great accuracy and if the distances are not worked out precisely. In cartoons, as a rule, very slow motion should be avoided. It is better left to live action. If it must be done, make sure that the movement contains sufficient rhythm, bounce and flexibility. The drawings also need extremely careful tracing. Sometimes it is preferable to advance the animation by short camera dissolves (a camera fade of one image into another) or by adding digital motion blur, rather than laboriously filling in every inbetween.

If the animated drawings are close and accurate enough, three or even four frame exposures are possible per drawing. In close up, however, this might appear too jerky. It is highly advisable to study an animation line test to ensure that the desired effect has been achieved. Sometimes Japanese and Korean anime will allow for timing characters on fours or even six frame exposures, but this is not so much an attempt to recreate natural motion, as a stylized convention it's audience had learned to accept.

FIGURE 23 Enlarged film frames from *Animal Farm* showing an extremely slow movement of the character Napoleon ascending to the top of a barn on a ladder. Occasionally, as in this case, it is permissible to apply three frames for each movement. The animation is so slow and the intervals are so close to each other that the movement does not appear jerky and the audience will not notice the difference.

Timing a Fast Action

Fast rather than slow action suits animation best. It gives the animator an opportunity to create an illusion of pace and energy which is much more difficult to achieve with live action.

The important point to remember about timing fast action is that the faster the movement is, the more important it is to make sure the audience can follow what is happening. The action must not be so fast that the audience cannot read it and understand the meaning of it.

With fast action *anticipation* is very important indeed. The character prepares for the action he is about to do so that the audience is ready for the quick movement when it comes, and so can follow it even though it may be very rapid. In an extreme case, for example where a character zips off screen, the

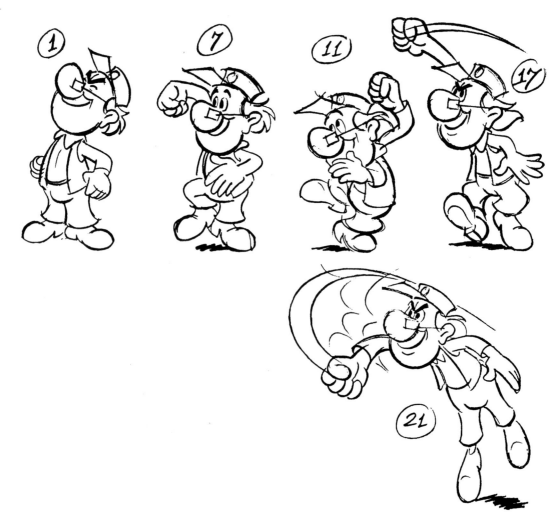

anticipation alone is sufficient and it is possible to miss out the zip altogether or perhaps dissolve it into a puff of smoke or 'whizz' lines (see page 113). Modern digital techniques enable the artist to add a motion blur in between fast key poses, imitating the eye's inability to see fast actions as anything but a blur.

Of course there are times when anticipating every movement becomes tedious and it is necessary for dramatic effect to shock the audience with a surprise move. For example, if one character delivers a punch on the chin of another, it would be necessary to freeze the position of the fist at the end of the punch long enough for the audience to 'catch up' with what has happened. It might give more impact to shoot the fist out too far, bringing it back relatively slowly to the hold. This would give a bunching together of the drawings at the end of the punch, which would make it easier to read.

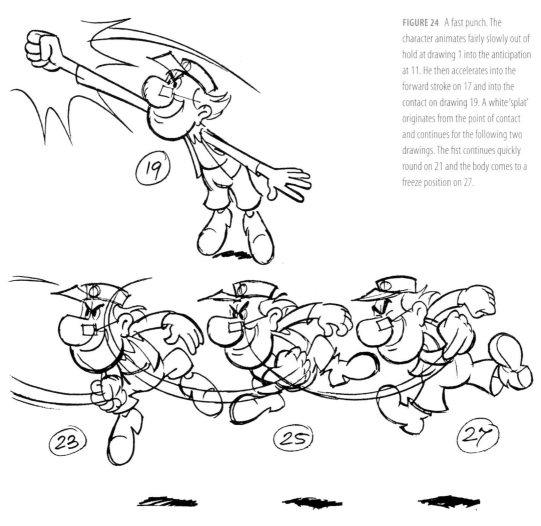

FIGURE 24 A fast punch. The character animates fairly slowly out of hold at drawing 1 into the anticipation at 11. He then accelerates into the forward stroke on 17 and into the contact on drawing 19. A white 'splat' originates from the point of contact and continues for the following two drawings. The fist continues quickly round on 21 and the body comes to a freeze position on 27.

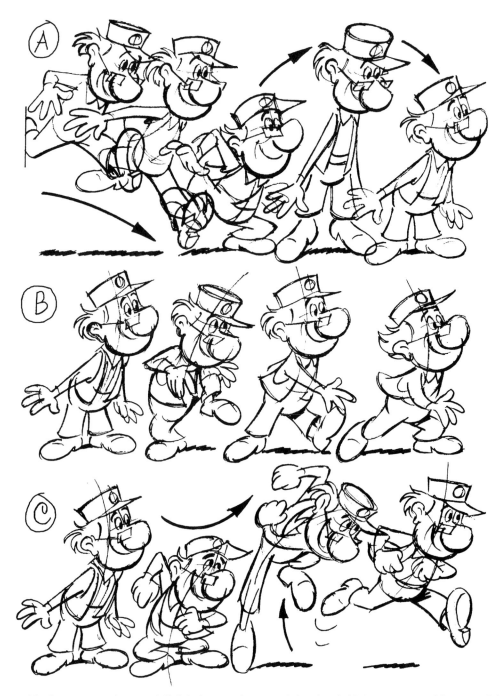

FIGURE 25 **A** The character runs in and comes to a hold. He lands in a squash position and rebounds too high before coming to pose. **B** To go into walk, he shifts his weight over his right foot so that he can lift his left foot, at the same time leaning into the direction of the walk. **C** Here he moves from the same pose into a run cycle.

Getting Into and Out of Holds

The time it takes to reach a hold depends on the momentum of the object or character. A heavy man running takes several seconds to come to a stop, whilst someone leaning forward to listen simply slows into a stop. In some studios this is called 'cushioning an action'.

Avoid having all parts of the figure coming to a stop at the same time. If a character jumps into a scene, for example, he might come in on an arc, squash, then recoil upwards too far before coming to rest in the final pose. Even after his body has stopped it may be effective to have his arms continue for another few frames. If the character has any loose extremities, such as coat-tails or feathers in his hat, these must take some time to stop. These would probably be drawn on separate eel levels to allow for this. When a figure comes to a hold, any extremities which have been trailing behind keep on moving then settle back, perhaps too far, before coming to rest (see page 61).

If a character makes a quick movement of surprise or perhaps winces, which shows a rapid tightening up of the muscles or a reflex withdrawal from danger, then he must go into the hold quickly. If the hold is made slowly in this case, the feeling of surprise is lost. With a quick stop such as this, it is even more important to have an overlap on the movement of the arms or hair, for example, to soften the sudden stop.

When moving out of a hold—'cushioning out', the spacing of the drawings usually gradually increases if the movement is fairly gentle. Any extremities hang back slightly until they are pulled along by the body. If the character goes into a more violent action, such as starting to walk, then the movement should be anticipated. The figure should draw back slightly before moving forward. As the front foot is raised the body begins to fall forward into the first step. If going into a run, the anticipation is more violent, with the body perhaps twisting away from the eventual direction of movement as the front foot is raised, and then leaning forward into the direction of movement so that the push on the back foot propels the body forwards.

Single Frames or Double Frames?
Ones or Twos?

Most things can be animated sufficiently well on double frames, 'twos', to make the added expense of single frames unnecessary. Sometimes an effect does not work when double framing is used, and then the extra drawings must be done. It is dangerous to animate on double frames during a table move 'pan' and/or camera track 'zoom' or 'truck'. These moves are usually done on single frames for smoothness and the combination of doubles and singles can produce effects of 'jitter'. Animation done on pegs which move on single frames, 'ones', must also be animated on single frames (see page 138). Animation to be matched to live action figures or characters has to be done with single frames or 'ones', since that would match the live action frames.

Broadly speaking and disregarding the above, the faster the action the more necessary it is to use single frames. In slow action, consecutive drawings are fairly close and the eye has no difficulty in jumping from one to the next, but

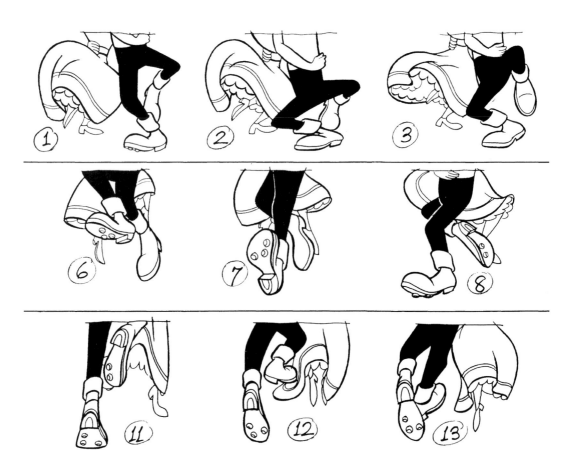

in fast action the timing may call for the drawings to be so widely spaced on double frames that the eye can no longer connect them up. Animation on single frames obviously halves the distance between consecutive drawings when the action is at the same speed on doubles.

When an action is very quick it is sometimes impossible to put enough information into the animation at double frames to explain what is happening. In a very fast run, which may need a cycle of eight frames or four frames to a step, then double frame animation of two drawings per step just does not work on the screen. This, therefore, must be done on singles, giving four drawings per step, although even these may need drybrushing or blur to make the action work.

Vibrating movements may also need single frames. A vibrating movement ABABAB, etc., with two frames on A and B, gives a surprisingly slow reverberation, so if a more snappy result is needed, single frames must be used (see page 62).

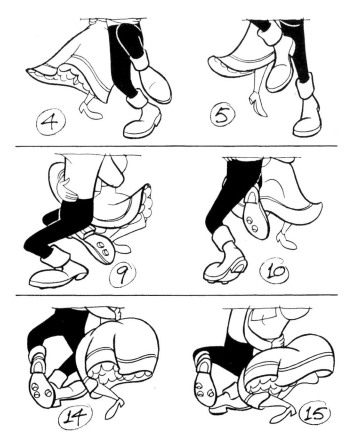

FIGURE 26 In timing a fast and continuous fluid action, inevitably single frame animation should be used. In the case of this quick dance fitted to a strong music beat of a folk or square dance, no other method would work. The figures turn around 360° and a very careful follow-through animation is essential to maintain the shapes of the figures. Once one cycle is animated, it is possible to repeat it several times.

How Long to Hold?

The general question of how long to hold subdivides into two questions:

1. How long is it mechanically possible for the object to hold?
2. How long is it necessary to hold to give the best dramatic effect?

The first question applied to inanimate objects is simply a matter of whether the object is in stable equilibrium.

With a living character, the same point applies. Once he has arrived in a stable, fairly comfortable-looking pose, he can hold it forever. On the other hand he should not hold at all, except for comic or other effect, in an off-balance pose. It does not matter how off-balance or awkward an extreme looks, provided it is reached properly and is moved out of fairly quickly.

A drawing that works as a hold is really a different kind from a normal animation drawing that works as one of a series. A held drawing can usually be extracted from the animation and works when framed and hung on the wall, whereas most animation drawings do not. A held drawing normally has a balanced look to it, although the subject can be either in a state of tension or relaxed. A relaxed or passive pose can be held forever (listening, thinking,

FIGURE 27 **A** A static gag, based on a joke drawing. The character raises the cymbals and holds there for 24 frames before a pan away to another member of the orchestra. (From *Symphony Orchestra* by Halas and Batchelor.) **D** The 'freeze' position at the end of a fast throw, held for about 12 frames.

reading, etc). If the design of the characters is more graphic and stylized, then a long hold is more believable than a realistically drawn figure held, which might look frozen to the audience. In the case of a realistic figure, a moving hold is desirable. The figure at rest blinks every three to five seconds, shifts its weight from one foot to another, etc.

B The plug is held for 32 frames (with gurgling sound effect). **C** The man stands up quickly and his body is held for 8 frames. **E** A 'look' off screen needs a hold of about 12 frames before cutting to what the character sees. **F** Allow about 16 frames for each word of a title card for reading time.

Anticipation

One of the tricks an animator has to learn is how to attract the attention of the audience to the right part of the screen at the right moment. This is of great importance to prevent the audience missing some vital action and so the thread of the story. Although the audience is a group of individuals, the human brain works in a predictable way in these circumstances and it is possible to rely fairly confidently on reflex audience reaction.

If there are a number of static objects on the screen with the attention equally divided between them and suddenly one of the objects moves, all eyes go to the moving object about {1/5} second later. Movement is, in effect, a signal to attract attention. If, therefore, a preliminary movement is made before the main movement, such as drawing back the foot before a kick, the attention of the audience can be attracted to the foot. This ensures that they will see the kick when it comes.

The amount of anticipation used considerably affects the speed of the action that follows it. If the audience can be led to expect something to happen then the action, when it does take place, can be very fast indeed without them losing the thread of what is going on. If the audience is not prepared for something that happens very quickly, they may miss it. In this case the action has to be slower.

In an extreme case, if the anticipation is properly done, the action itself needs only to be suggested for the audience to accept it. For instance, if a character is to zip off screen it is enough for him to draw back in preparation, followed by perhaps one or two drawings to start the forward movement. A few drybrush speed lines or a puff of dust can then imply that he has gone (see the Drybrush section on page 112 for a definition of the technique). These lines or dust should be made to disperse fairly slowly—probably in not less than 12 frames.

FIGURE 28 Since movement attracts the attention of the audience, their attention will be focused where motion takes place. **A** Simple anticipation of a grab. This can be more or less exaggerated according to circumstances. The character moves from rest into the anticipation at 2, then into the grab position at 3. **B** A more violent movement needing stronger anticipation. This is on 2, before the main action on 3.

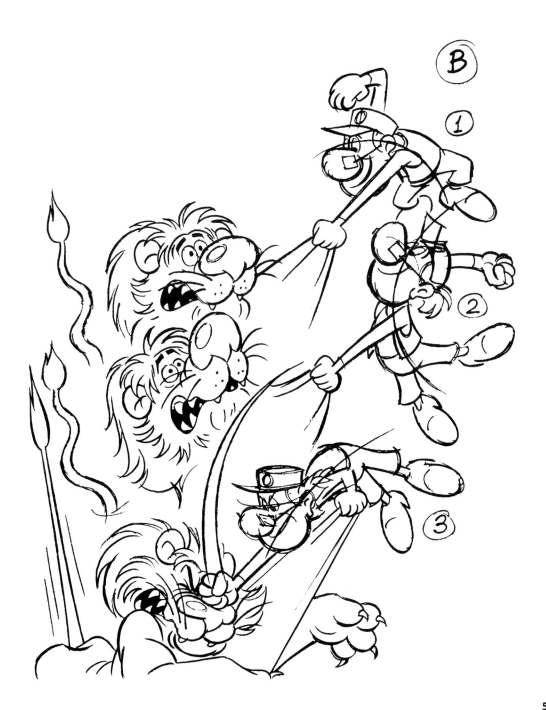

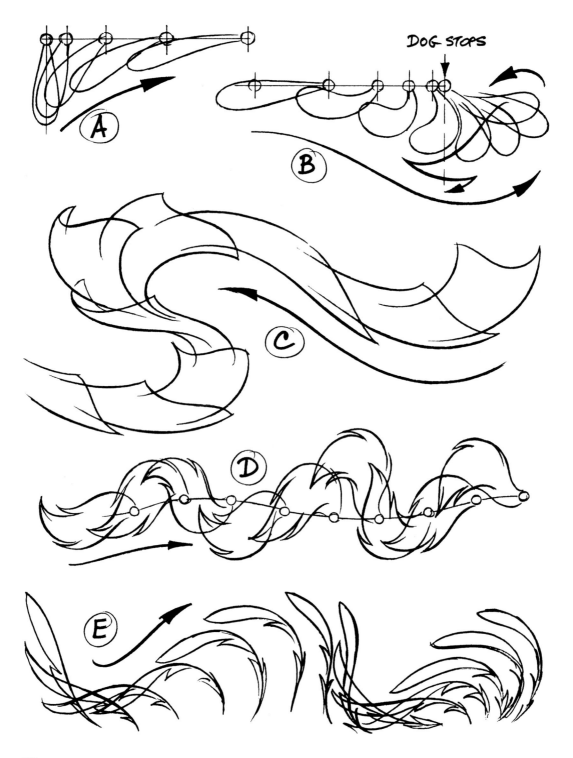

DOG STOPS

A

B

C

D

E

Follow Through

The animation of an extremity, such as a coat-tail or a feather in the hat, is difficult to key at the same time as the character to which it belongs. Objects of this nature move to some extent independently of the character they are attached to. It is, therefore, difficult to predict where they will be a few frames ahead without following their movement drawing-by-drawing. The movement of an extremity depends on:

1. The action of the character.
2. The extremity's own weight and degree of flexibility.
3. Air resistance.

Imagine a dog with floppy ears, which hang vertically when the dog is still. When the dog accelerates away the ears tend to stay behind but are pulled forward. As long as the dog does not slow down, the ears trail out behind, with a wave motion if the dog's head goes up and down. If the dog slows down and stops, the ears try to continue forward, and may stretch forwards before swinging backward again and finally coming to rest. An attempt to key this movement with the dog is almost certain to fail. For instance, the ear may be moving at its fastest as the dog is coming to rest.

Similarly, a cloak of heavy cloth moves independently as a result of the movement of the character's shoulders. It is important for the fluidity of the animation that the cloak is allowed to continue with its own speed and direction when the shoulders change their speed and direction. As a cloak is a large area, air resistance may be important too, particularly if the cloth is light. The movement of a gauze veil, for example, is governed almost entirely by air resistance, trailing behind the character and drifting slowly to rest after the character does.

FIGURE 29 To maintain fluid animation it is essential to treat the weight of a body differently from its accessories or extremities. **A** A simplified dog's ear and its attachment to the dog. As the dog accelerates away the ear trails behind. **B** When the dog stops, the ear tends to continue forwards at the same speed before swinging to rest. **C** Cloth trails in a way that combines the effects of its weight and the air resistance. **D** A horse's tail. **E** A feather, which is more springy than the other examples.

FIGURE 30 A A dog jumps in and stops. The front legs squash on 2 and the back legs on 4. The head and front legs are static on 5, although the back legs, tail and ears are still moving. **B–F** Five balls bouncing: B, C and E are together; D is overlapped one frame late and F one frame early.

Overlapping Action

It is usually a good idea in animation to have a time lag between the movements of different parts of the figure. This is called 'overlapping action'. In a slow, gentle action this may not be necessary, but in a more violent movement it helps to give fluidity.

If several characters are dancing in unison on the screen, that is, using the same animation traced off several times, their movements look much more alive and fluid with an overlap of one or two frames on some of the characters. The result is that these characters are just out of sync with the others, which appears less mechanical than having them exactly in unison. Trained soldiers marching, when the effect should be rather machine-like, should of course be timed exactly together. For a squad of new recruits, however, a four frame overlap on some of them may not be enough to give a ragged look to their marching.

Imagine a dog running along and coming to a stop. The first things to stop are probably his front feet, then his back legs and feet come up behind. As he has gone into a 'squash' onto the front feet at first, once all four feet are firmly on the ground he comes out of this and might even go up too high and settle back into the final pose. If he has floppy ears, these are probably the last things to come to rest.

The principle on which overlapping action is based is really only that of momentum, inertia and action through a flexible joint as discussed on page 38. The reason it works so well in animation is that the natural tendencies of movement work in this way, and these are picked up and exaggerated.

G A loosely rattling car can be built up, for example, in four drawings. The bonnet and the door can be keyed on the top scale, two wheels and one mudguard on the second scale, the steering wheel and the front bumper on the third scale, and so on. In this way the movement of each part of the car can be made to overlap with the part next to it as far as possible. The amount of movement depends on the circumstances.

Timing an Oscillating Movement

A fast vibrating movement, such as a spring twanging can be done as shown in Fig. A. The movement between the extremes is so fast that no in-between drawings are necessary. It is only necessary to show the extreme positions of the spring getting gradually closer to the rest position. The vibration of a larger and heavier object, such as a springboard just after a diver has left it, is timed more slowly, taking perhaps four frames to go from the bottom of the movement to the top. In any action in which the direction of movement reverses at an extreme, it tends to come out of the extreme more slowly than going into it. This gives more 'snap' to the movement. Cycles of less than six frames may look mechanical and it may be worth doubling the length of the cycle with two different variations of the movement or, instead of using a repeat of four frames, use a double near-repeat of seven or nine frames, so that the same positions do not appear on two consecutive repeats.

The other type of inanimate repeat is discussed on page 80, in which the force of the wind causes a wave to move along a flag. A similar movement takes place when an animal wags its tail. The tail-wagging muscles can be considered as acting directly on the part of the tail next to the animal's body causing the lower section of the tail to move from side to side. As the tail is flexible this movement is transmitted to the next, higher section with a slight time lag. The movement of this second section is then passed on with another time lag, and so on to the end.

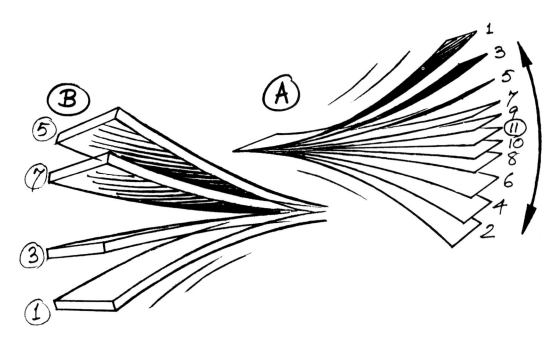

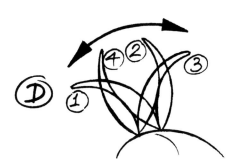

FIGURE 31 **A** A vibrating spring animated on single frames. **B** The slower vibration of a springboard. **C** A repeat cycle of an animal's tail wagging. **D** The quicker wag of a dog's tail, on double frames. **E** A surprised reaction, or 'take', can be achieved by inbetweening the character from 1 to 13 on odd numbers and from 2 to 13 on even numbers. If the drawings are shot consecutively a vibrating movement is achieved, coming to rest on 13.

Timing to Suggest Weight and Force—1

Each part of the body moves as a result of the action of muscles, or as a result of the movement of another part of the body to which it is attached. For instance in Fig. A, when the arm is raised, the upper arm tends to be raised first by the shoulder muscles. As the elbow is a flexible joint, there is a time lag before the forearm starts to move and similarly another time lag before the hand moves.

In a walk, the knee is a hinge joint and the ankle acts almost like a ball and socket joint. If the angle between the shin and the foot is kept the same, the ankle joint appears to be rigid, so this angle must vary. In Fig. B, the foot starts on the ground (position 1) and is lifted forward for the step. The knee is raised, but the foot tends to hang back, and so comes up heel first. The toe trails downwards until the top of the movement (position 4), but as the leg straightens the foot tends to keep going up and so, as the heel goes down, the foot rotates until the heel hits the ground (positions 5 and 6). The foot now tends to continue its downward movement, but as it is stopped by the ground it quickly slaps down flat.

If, as in Fig. C, a character is to give a strong pull on a rope, the first part of the body to move is probably the hips, followed by the shoulders, the arms and finally by the rope. The amount of movement depends on the strength of the character, the weight on the other end of the rope and the mood of the scene, but the order in which different parts of the movement take place is the same.

If, in the same situation, the character is being pulled by a force at the other end of the rope, as in Fig. D, then the order of events is reversed. First the rope moves, then the arm, the shoulders and the hips. The first part of the pull

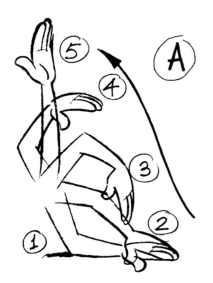

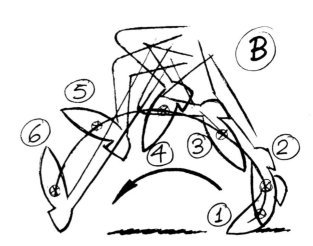

takes up the slack in the rope and, if the movement is fast, the shoulders do not move until the rope and the arms have been pulled into a straight line. At this point the shoulders jerk forward and the character tends to pull out into a straight line as he goes out of screen. In a slow, steady pull the character may have time to react and try to resist.

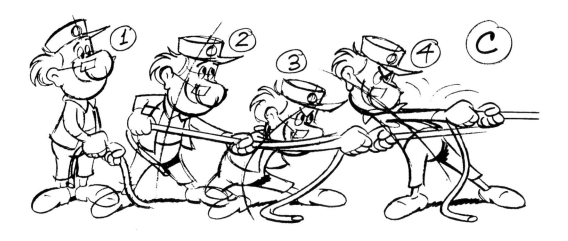

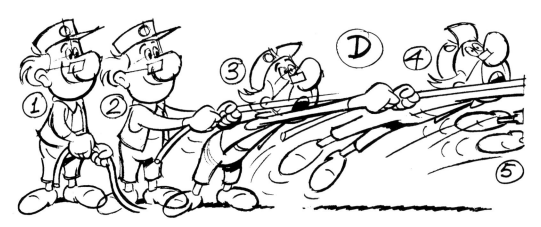

FIGURE 32 **A** Raising an arm—showing the effect of flexible joints. **B** In a walk, the flexible ankle joint results in the foot railing downwards as the ankle goes up on drawings 2 and 3, and trailing upwards as the ankle goes down on drawings 5 and 6. **C** The sequence of events when a man pulls on a rope. On drawing 2 he takes up the slack, on 3 he starts to move his body weight backward, and on 4 he leans back on the rope. **D** When the rope itself is jerked, the man's arms are drawn forwards until they are in a straight line with the rope. At this point his shoulders are pulled forward in drawing 3, and in 4 and 5 his whole body is dragged away.

Timing to Suggest Weight and Force—2

To give the impression that a character is wielding a heavy hammer it is important to time the movement carefully.

The start position is as Fig. 1. The man is relaxed with the hammerhead resting on the peg that he is going to hit. To start the movement he lifts the hammer. If it is heavy, he cannot do this in the position shown in Fig. 1 A as he would then be off-balance and would topple over. In order to transfer the weight of the hammer over his feet so that he is balanced, he must step forward and grasp the hammer near its head (Fig. 2). He can now slide the hammer toward

FIGURE 33 To make the hammer look heavy, the man must keep the weight of the hammerhead more or less balanced above his feet, until he hits the ground with it. Only a light hammer could be lifted, as in 1 A, without the man falling over.

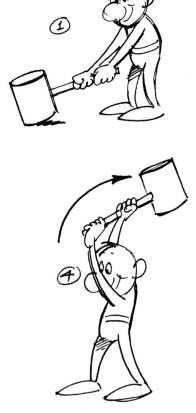

himself and lift it above his widely spaced feet (Fig. 3). As the head of the hammer rises above shoulder level, he starts to move its weight backward in preparation for the forward action. However he cannot let it go too far behind him or he would overbalance backward (Fig. 4). So he starts to move his body weight forward, and this eventually starts the hammerhead moving forward (Fig. 5). He jerks his body forwards and downwards to give a forward impetus (Fig. 6) and the job is done. Now he need only step back and the hammer will fall and hit the peg. This position links up to Fig. 1 or at least Fig. 2.

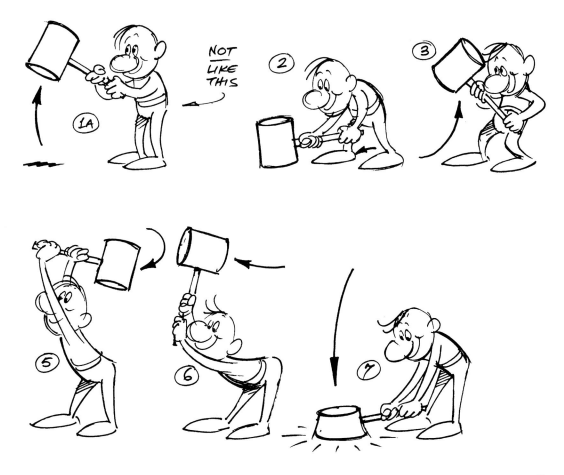

Timing to Suggest Weight and Force—3

In an energetic repeated movement, for example, a man hitting something with a pitchfork, the different parts of the figure move in a particular way to give the maximum feeling of effort.

Drawing 1 shows the impact of the pitchfork with the ground. The end of the pitchfork remains in contact with the ground for drawings 2–4, whilst the body begins to move out of the extreme position in readiness for the next stroke. The shoulders arrive at their furthest backward position in drawing 7

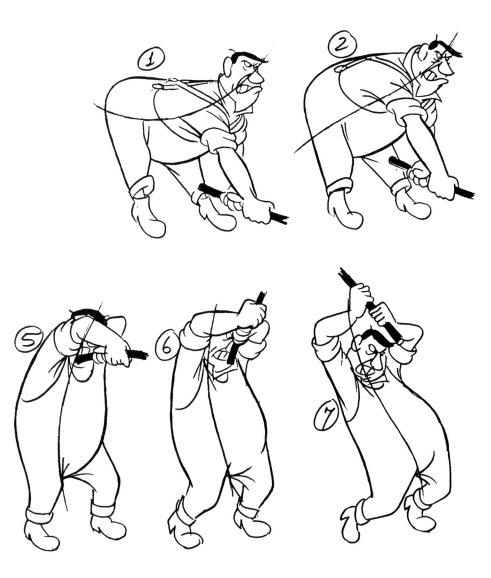

and begin to move forwards again in drawing 8, although the head of the pitchfork is still moving backward. In drawing 9, the hips move quickly backward as the shoulders and arms come forward and downwards, leaving a big gap between the position of the pitchfork in this drawing and that in drawing 1 to give a final impact to the movement. Note how the curvature of the body changes from convex to concave by means of 'S' curves on drawings 2 and 7.

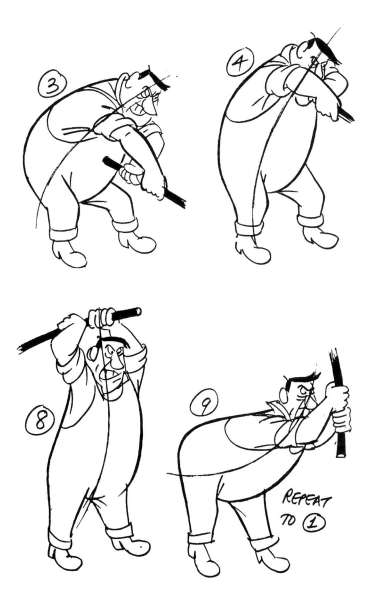

FIGURE 34 The man is repeatedly hitting something on the ground with a pitchfork. Note how the weight of the body is maneuvred to get the maximum effort into the impact on drawing 1.

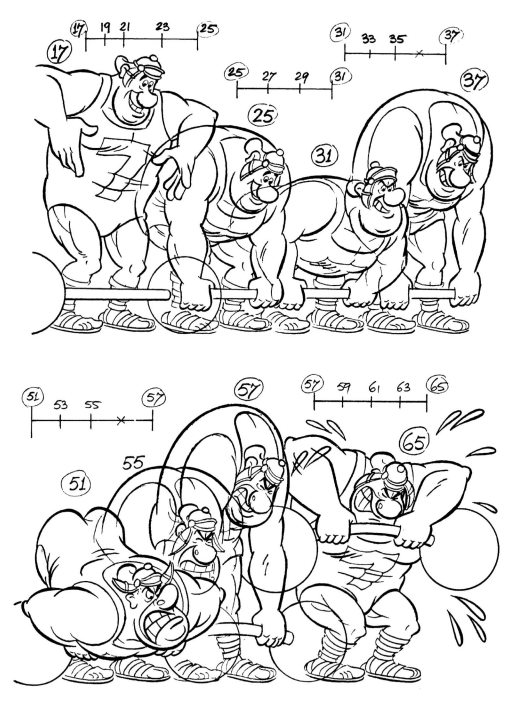

FIGURE 35 On drawing 17 the Roman athlete confidently prepares to lift the heavy barbell. He anticipates on drawing 31 and tries to lift on drawing 37. The weight does not move so he makes a much bigger anticipation on drawing 51 and a big jerk on drawing 57, which enables him to get the weight up in the air on drawing 65, before collapsing with exhaustion.

Timing to Suggest Weight and Force—4

An athlete is going to lift the heavy barbell. He starts confidently, and in drawing 17 is anticipating grabbing the bar. He grabs the bar on 25, and 31 is the anticipation to the first attempted lift. He is still confident but grits his teeth somewhat as he makes the effort, as shown in drawing 37. The bar bell does not move. After 37 he comes to a puzzled hold as he realizes he has a more difficult problem than he thought. In drawing 57, he makes a much bigger jerk after making a more determined and annoyed anticipation in drawing 51. After this jerk, he manages to lift the barbell with great difficulty. A few frames after drawing 65, he collapses out of screen under the weight.

FIGURE 34A Scene from *Idiots & Angels*, by Bill Plympton.

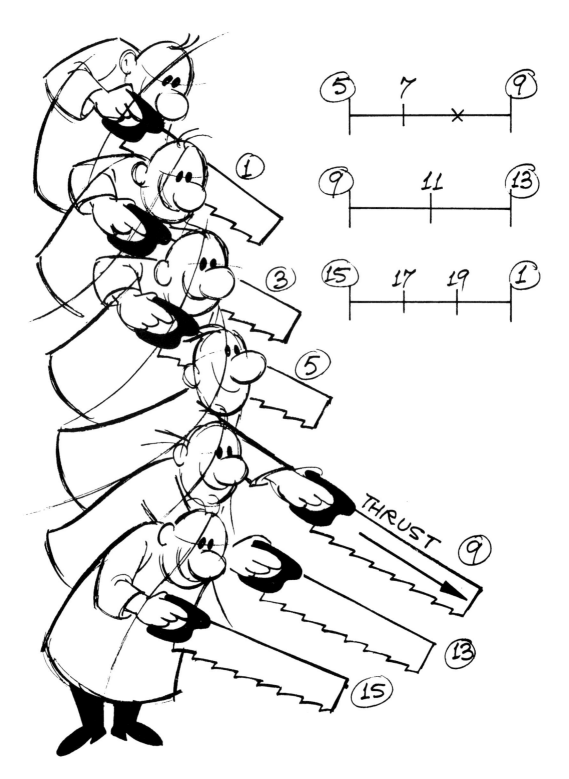

Timing to Suggest Force: Repeat Action

In a repetitive to and fro action such as sawing, it is not sufficient to draw the forward and backward extremes and then inbetween them. To convey the feeling of effort being put into the action, it is necessary to analyze the relationship in time between the movement of the body weight, the muscles of the arm, and the action of the saw. This can be done by actual or mental miming. If a lot of effort is needed to push the saw through the wood, this cannot be supplied by the arm muscles alone, as straightening and bending the arm would move the shoulder back and forth as well as the saw. Immediately before straightening the arm, the whole body weight must be moved forward, so that when the arm does straighten it does so against the forward momentum of the body weight, and so the thrust is applied to the saw. The thrust is increased by rotating the shoulders at the same time.

When sawing with the right hand the right shoulder is held back during the beginning of the forward body movement, then it is quickly brought forward, followed immediately by the straightening of the right arm, which puts the full effort of the movement into the action of the saw. On the return stroke, little effort is required in the movement of the saw, which cuts only on the forward stroke, and so the sequence of events is less complicated. Some time lag between the backward movement of the body and the saw makes the animation more fluid, but otherwise straightforward in-between drawings are sufficient.

FIGURE 36 In a repeated movement such as sawing, the action is basically forward and backward between 1 and 9. However, to give a feeling of effort, intermediate keys—5 and 9—are also needed. Of these 5 is more important, as the weight of the body comes forward before the final thrust is given to the right arm.

Character Reactions and 'Takes'

A further advantage which animation can claim over live action is the ease with which character reactions can be controlled and exaggerated. Without some degree of exaggeration, cartoon animation would not look right. The success of such effects lies in timing.

A character makes a 'take' when he suddenly sees or becomes aware of something that makes him react in surprise. There may be a short or long time lag between when the character sees whatever it is, and when the message gets through to his brain. This would be at least five frames, but could be a lot longer depending on the character's mental ability.

The first principle is to coordinate the character's body movement with his facial expression. The legs, arms, hands, the position of the body—all must contribute to a reaction. The facial expression must be emphasized with adequate exaggeration, particularly of the eyes and mouth.

In Figs A and B, both characters start with a hold on drawing 1, whilst the message is transmitted to the brain, then both go down to an anticipation or 'squash' position. They are then both animated up to a position beyond that in which they eventually come to rest. This 'overshoot' (Fig. A9 and Fig. B5) is the drawing that gives the feeling of surprise in each case, but the hold at the end (Fig. A13 and Fig. B7) is the drawing that the audience sees. The latter is, therefore, the one in which the face should project the character's full reaction.

There are, of course, differences in reaction according to the type of character portrayed. A big brainless character requires a longer time to react than a small excitable character. This is where character animation can excel on its own, and where the art of animation begins.

FIGURE 37 **A** Note that the action of surprise from drawings 1 to 13 is strengthened by a preparatory gesture in drawing 5 and an overshoot on drawing 9. **B** Similarly this character's expression is underlined by key drawing 3 that drives home dramatically the surprise expressed in key drawing 7 which would hold for perhaps 12 frames. (From *Hamilton*, TV series by Halas and Batchelor.)

Timing to Give a Feeling of Size

The way a movement is timed can contribute greatly to the feeling of size and scale of an object or character. When animating a man with naturalistic proportions, his movements may be timed as he would perform them in real life. If, however, he is to appear as a large giant, his actions must be retimed. As a giant he has much more weight, more mass, more momentum, more inertia; he moves more slowly than a normal man. He takes more time to get started and once moving takes more time to stop. In fact any changes of movement take place more slowly.

Conversely, a tiny character, such as Tom Thumb, has less momentum, less inertia than normal and so his movements tend to be quicker.

The animated films of legendary Japanese director Hayao Miyazaki show particular skill in illustrating, in both layout and movement, the relationship between large objects and smaller figures. In his 1984 film *Nausicaä of the Valley of Wind* (*Kaze no Tani no Naushika*), fantastically huge flying aircraft

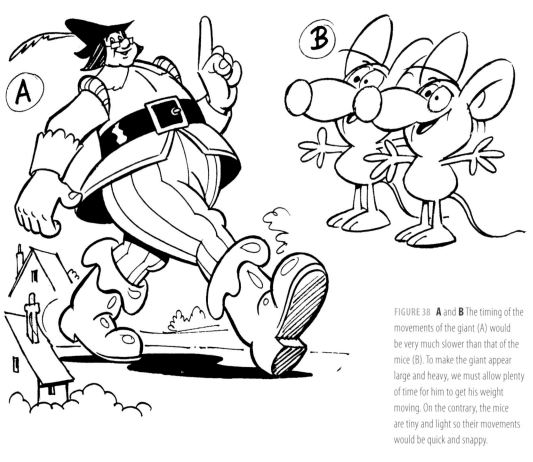

FIGURE 38 **A** and **B** The timing of the movements of the giant (A) would be very much slower than that of the mice (B). To make the giant appear large and heavy, we must allow plenty of time for him to get his weight moving. On the contrary, the mice are tiny and light so their movements would be quick and snappy.

come down into a valley, with people and smaller craft scampering around them. The timing of the airplanes reflects their immense size, while the tiny humans move faster.

In nature it is possible to gauge roughly the scale of an object as it falls. For instance, if a model car is filmed going over a cliff edge and it hits the ground half a second later, it is immediately obvious that this is a model car and the cliff is about 1.2 meters high. If the same action is filmed with a high-speed camera and projected at normal speed, the car takes about four seconds to reach the bottom of the cliff. If there is nothing else to judge the scale by, the brain is then deluded into thinking that it is a full sized car, and that the cliff is about 80 meters high.

The action of flames is similarly affected by the scale of the fire. A small flame flickers quite quickly, whereas the flames of a large fire have a slower, wave-like movement (see page 45).

FIGURE 39 An image from the Japanese animated motion picture entitled *Kaze no Tani no Naushika* (*Nausicaä of the Valley of the Wind*). (© 1984 Nibariki – GH)

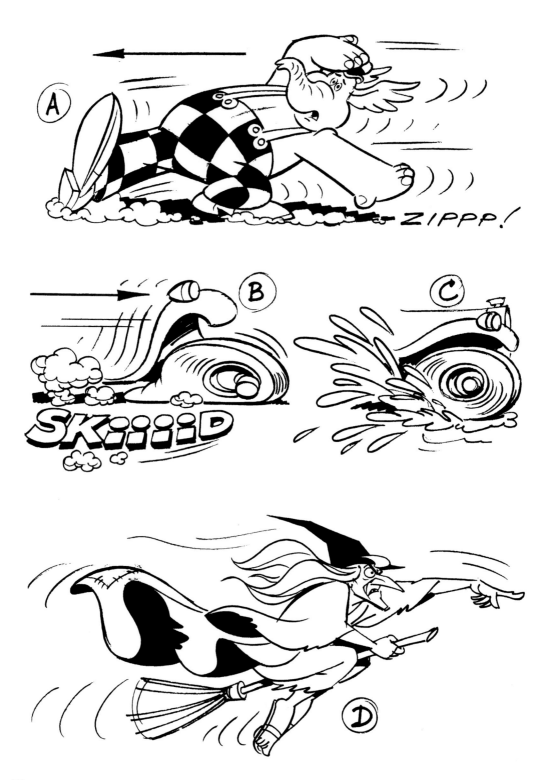

The Effects of Friction, Air Resistance and Wind

Imagine a cartoon elephant running along. He wants to make a sudden stop. How should he be animated? If he is on an ice rink, it is difficult to see how he can stop. It might be possible to turn him round and make him work his legs as though running in the opposite direction. On ice, he would get little purchase and so this method would produce little result. If he is on a normal surface he can use the friction between the ground and his feet to slow himself down. The animator must, however, arrange the elephant's weight to be as far as possible behind his feet as he slows down. If he was upright, the friction would slow down his feet, but the upper part of his body would continue moving quickly and he would fall forwards. So his body must lean backward. He might go into this position with a slight jump to achieve the maximum effect of his weight bearing down onto his feet. With his back foot covering the maximum area of ground for friction and his front heel ploughing into the ground for maximum braking effect, he can stop quickly. As he stops he must bring his body upright to avoid falling backward.

Similarly, if a man applies the brakes suddenly in a motor car it may be effective to draw the car in a backward-leaning position, with the tires squashed so that they have as large an area as possible in contact with the road. If the hubs press forward against the tyres whilst the friction from the road surface stretches them backward and the driver leans back pulling on the brake lever, a good effect should result.

Wind is a useful device to give life to an animated object. It can very occasionally be animated as drybrush but is usually shown by its effects. Leaves are swept along, trees bend and wave according to the wind speed, and so on. Moving air flows and eddies around objects in much the same way as water does. Light objects, such as dead leaves, are swept along more or less at wind speed in curves and eddies.

There is usually an area of calm air in the lee of a solid object in which windswept material collects. Driving snow does not make a drift until the wind meets an object such as a wall. The snow is then deposited against the wall.

Anything fairly flexible, such as a plant or a tree, has its own natural vibration period, depending on its length, like an inverted pendulum. When blown by gusty wind, such an object tends to sway in this natural rhythm. A tall tree might sway to and fro in two or three seconds and a plant in less than one second.

The speed and mood of the wind is also well shown by curtains, waving flags and clothing, the animation of which can be graduated from a slow, languorous wave to a violent, rapid flutter as the cloth strains to tear itself from its support.

FIGURE 40 **A** The elephant is trying to apply as much friction as possible to slow himself down on a slippery surface. He keeps his weight low down as he leans backward and digs his front heel into the ground. **B** A possible distortion caused by an extreme tire skid. The car and the axle tend to continue forwards, whilst the tire and the wheel hub are pressed backward by the friction of the ground. **C** A spinning car wheel throws up dirt, mud, etc., because of friction. **D** Air resistance causes the extremities of the witch, i.e. the hat, feet, etc., to bend backward. Her long hair and clothes flow in the wind in a series of waves (see page 81).

79

Timing Cycles—How Long a Repeat?

The old saying has been that when an audience is aware of a cycle, the cycle is a failure. If the animator uses cycles in a clever way and disguises them well, the audience will never be aware they are watching repeated actions. A naturally repetitive movement, like that of a piston, or a run, can have quite a short cycle. A run might take eight or 10 frames for two paces and would probably need one drawing per frame. A cycle of two people dancing together could be 16 frames or more, but could repeat many times without seeming repetitive.

Other actions, such as a fire burning, which are not repetitive by nature, require extra cycles of approximately one second or more. The number of extra cycles required to add variation to the movement depends upon the number of times it is to be repeated.

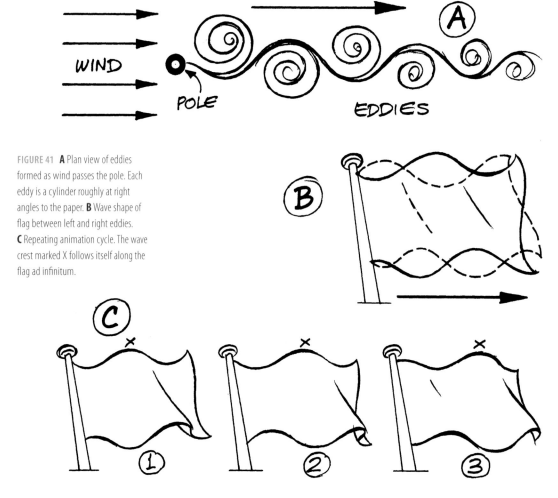

FIGURE 41 **A** Plan view of eddies formed as wind passes the pole. Each eddy is a cylinder roughly at right angles to the paper. **B** Wave shape of flag between left and right eddies. **C** Repeating animation cycle. The wave crest marked X follows itself along the flag ad infinitum.

Another example that would need a repeat of a second or more is smoke. This can be arranged so that the repeats on the drawings become closer and closer together at the top, so that the speed diminishes as the smoke breaks up and disappears.

If a snow cycle is either to be run for a long time or to be used in several scenes, it needs a cycle of several seconds so that the repeats are not apparent. If it is animated on several levels (foreground, middle distance and distant) and the three cycles are made of different lengths, they repeat differently each time round and give the effect of a very long cycle.

A Waving Flag

The movement of a flag in the wind is an example of a wave movement, which is used very often in animation.

Seen in a simplified form (Fig. A), a steady wind is split into eddies on alternate sides of the flagpole, looking much like the wake of a ship in water. Each of these eddies is roughly a cylinder, more or less at right angles to the paper. A flag attached to the pole is blown to the right and assumes a wave shape, sandwiched between the alternate eddies (Fig. B). The cloth of the flag makes the movement of the wind visible. As the eddies follow one another to the right, so the waves in the cloth follow one another along the flag.

Fig. C shows a simplified repeat cycle of this. The wave crest marked X travels along the top of the flag to the right, followed by a trough caused by the alternate eddy. This is followed by another crest similar to X which can be animated into X again to complete the cycle.

Note that in this kind of movement there is no actual 'key' drawing. All the drawings are of equal importance in the series and each one must flow smoothly to the next.

Depending on the length of the scene it is advisable to draw one or two variations that can be introduced to give more interest to the repeat.

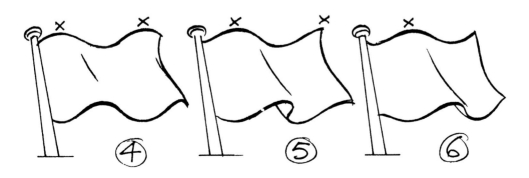

Multiple Character Scenes

At times you may be asked to animate a scene in which two or more figures are moving in the same shot. You have to plan the motion so as not to cloud the scene's intent with a lot of extraneous movement. Motions occurring at opposite sides of the screen at random could divide and distract your audience's attention. Just like a dance choreographer is always aware of which dancer the audience should focus on, so should the animator be aware of the primary character in a scene. The supporting characters have to move little enough to be alive, reacting to the primary character's actions, but not move so as to be distracting. Characters in the far background could move very little or hold, since the audience will sense them only peripherally. This process has become more difficult in digital animation since the director may change his or her mind as to where the camera is, thus negating your graphic strategy.

Digital Crowd Scenes

Modern 3D programs like *Massive* have given us the ability to move large numbers of characters in a relatively easy way. The pre-programmed behavior of characters can be multiplied endless times and placed either close up or far in the distance. Like a choreographer, the animator has to be as much in control of the overall sweep of the action as in the minute poses of the individual figures. For instance, a swarm of cavalry led by a war chief waving his sword rides up from the distance, and sweeps around behind a line of enemy war elephants. The animator may create four or more individual cycle actions and place them at differing speeds, to create enough variance in the motion to make the actions seem random. If the actions of two or more figures set too close together move in unison, like synchronized swimmers, the natural effect will be lost.

Newer versions of the software allow for more complex crowd behavior: figures avoiding the elephants, swinging a sword once close enough to the enemy, running away if outmatched, etc. Figures up close to the foreground should be animated as a customized performance, as the audiences will be more aware of their actions than the figures far in the back. The artist should just take care not to become too complacent and think the software will do all the work for them. You must think of adding one or more figures doing a singularly customized action, and place them in an area where they will be seen. This will complete the illusion of randomness. Special effects like occasional arrows flying through the scene, smoke and dust can be layered over to further mask the repetition of the characters cycles. The Walt Disney classic *101 Dalmatians* (1961) was full of cycles and reused movement. Yet because these are so skillfully hidden, the audience is unaware of these tricks.

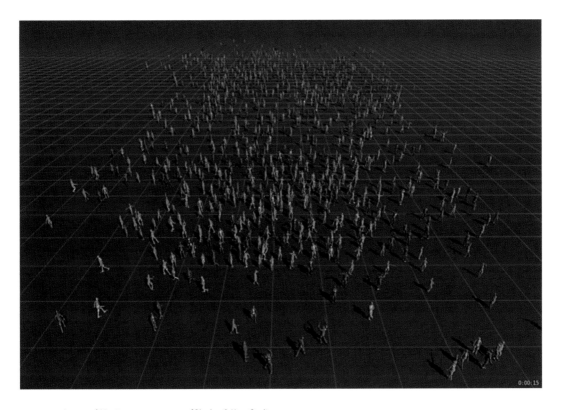

FIGURE 42 A scene of *Massive* avatars, courtesy of Rhythm & Hues Studios.

Effects Animation: Flames and Smoke

The movement of flames is governed by the movements of air currents above the fire. The hottest part of a fire is in the center and above this the hot air rises. As it rises it is replaced by colder air rushing inwards from the sides. This air in its turn is heated and rises, and so the process is continuous. This flow of air usually gives a roughly conical shape to the flames, with a succession of indentations representing eddies of cold air, starting at the base of the fire and moving inwards and upwards.

The timing of these movements is fastest at the base, where the fire is hottest, slowing down on the way up. As the individual flames taper off, break up into smaller pieces and disappear, so the speed should diminish also. The shapes must be kept fluid and ever-changing, although they should still be identifiable as smoothly rising areas of flame. If areas of flame stick in one place or even appear to animate downwards, this ruins the effect.

The timing of the flames also depends on the size of the fire. A big fire is hotter than a small one and, therefore, much bigger volumes of air are involved. Obviously, in a big fire an individual flame takes longer to work its way from the base of the fire to the top, probably several seconds, whilst in a small fire it might only take a few frames.

Flames are volumes of gas which can ignite or die out quite suddenly, and can therefore change their volume quickly from one drawing to the next—against the normal rule in animation that volumes should stay the same. Surges of flame usually appear quickly and die away more slowly.

Smoke can be treated in many ways but the main timing problem is how to plan a repeat which does not appear too mechanical.

One way of doing this is illustrated on page 85. A variation on this basic idea is to animate puffs arranged on a wave pattern. These may remain as individual puffs or merge into one another to form an irregular column. A cycle of this type of smoke would take 32 frames or more.

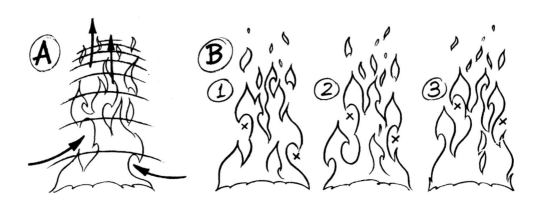

A succession of quick puffs, as from a car exhaust, if repeated, may need two or more different shapes of puff, or perhaps alternating puffs and smoke rings, as the same puff repeated looks mechanical.

A really big column of smoke rising from a fire forms a mushroom or smoke ring—a doughnut-shaped eddy with a hole in the middle.

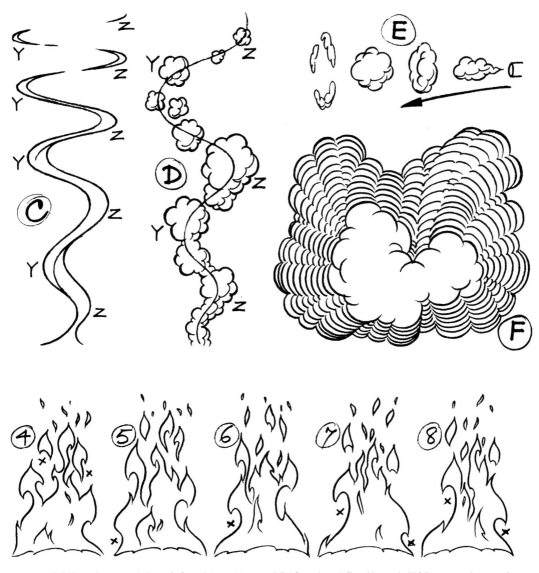

FIGURE 43 **A** Cold air is drawn in at the base of a fire and rises as it is warmed. **B** A fire cycle: 1–8. The eddies marked X follow one another upwards, slowing down as they rise. **C** and **D** Alternative smoke cycles. Points Y animate upwards to Y, and points Z to Z. **E** Car exhaust cycle. **F** Billowing smoke—showing introduction of new arcs.

Water

Water moves in a very characteristic way as it has no mechanical strength and is held together only weakly.

In a water splash, each little drop making up the mass of water at the start proceeds on its own trajectory, or parabola, regardless of what happens to any other part of the splash. In a splash, the water radiates from a central point. It starts as a mass of water, which spreads out into irregular sheets, held loosely together by surface tension. As it spreads out even further, the surface tension breaks down and the sheets disintegrate quite suddenly into drops that continue outwards individually.

FIGURE 44 Each part of the water in a splash proceeds on its own parabola, regardless of what happens to the rest of the splash. As the water radiates outwards it spreads into sheets, as in 7 and 8; then splits up into individual drops, as in 9. It is not necessary to animate out every drop individually—they can be left off a few at a time, provided the downward movement is maintained.

Take, for example, a heavy stone dropped into a lake. As the stone enters, some water is dispersed by it and this radiates upwards and outwards to form the splash. As the stone goes deeper it momentarily leaves a space behind it. This is rapidly filled by water coming in from all sides and as it meets in the middle the force causes a jet of water to erupt vertically in the middle of the splash. This usually splits into drops before falling back. So a splash of this kind must be timed as two separate events.

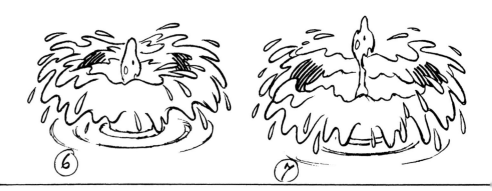

A large body falling into a tub would give a rather different effect. There is only a limited amount of water, and the body would force most of it out between itself and the sides of the tub. This would be similar to the first splash above, but there would be no secondary vertical jet.

Water under pressure can exert a considerable force. If a jet is directed upwards at an angle it describes a parabola, as each individual drop behaves like a ball thrown through the air (see page 32). If a jet of water hits a flat surface, the water is reflected back like light in a mirror, although with a good deal of random movement as well.

Water thrown from a bucket behaves like a splash. The water leaves the bucket as an irregularly shaped lump, which becomes streamlined in the direction of movement. Then individual parts of the water travel on their own parabolas, which diverge so that the water is stretched and then breaks into drops as before.

Drops can be made to animate smoothly by streamlining them into long narrow shapes and moving them along parabolas with a slight overlap in length between one drawing and the next. It is not necessary to follow each drop to its logical conclusion by animating it off screen or hitting the ground and splitting into smaller drops again. It is usually enough to slow down and diminish the sizes of the drops around the edge of a splash, eventually losing them altogether. This is effective as long as a lot of drops do not disappear on the same drawing but are allowed to vanish in a random way over a number of frames.

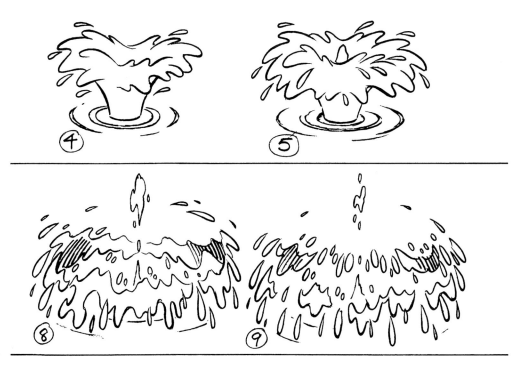

Effects around objects partially immersed in water are usually shown as ripples, which radiate from around the object and gradually split up and disappear. If the object is not moving or if it is moving in a cyclical way, then the effects can be made into a cycle. But if the object itself is animating, the effects must be animated continuously, which can mean a great deal of work.

A lot of work is involved in animating the disappearance of water spilt on the ground. This movement requires several seconds and is generally done by producing a series of holes in the water, increasing them in size until they coalesce and finally the water disappears. As far as possible such a situation should be avoided.

FIGURE 45 **A** Each drop of water in a hosepipe jet travels on its own parabola. Partial gaps in the jet help to avoid strobing in animation. **B** Semi-diagrammatic illustration of a jet from a moving nozzle.

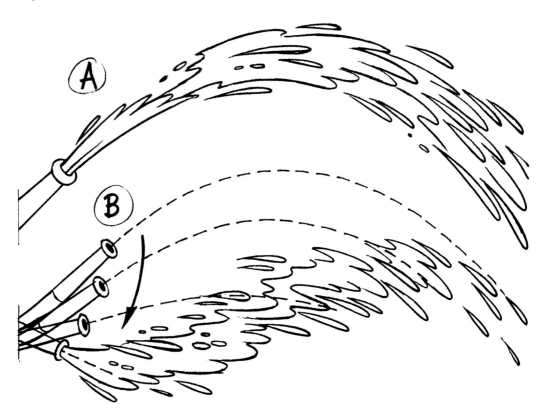

To achieve realistic liquidity, the timing for animation of water is quite critical.
If timed too slowly it looks oily or even treacly (like syrup), whilst if timed too
quickly it may fizz in a non-liquid-like way.

C Ripples from a partially submerged object are usually animated as concentric ellipses moving outwards and gradually disappearing. **D** Part of a cycle of
the reflection of a bright light in almost still water.

Rain

One problem with animating rain is that it can appear very mechanical. Some animators avoided the problem altogether by using live action footage of rain, shot against a black background and double exposed over the cartoon. But the aesthetic of animating rain is more desirable and gives the artist more control. Although rain actually falls in more or less parallel lines, it must be animated

FIGURE 46 **A** Tracks for foreground rain cycle. **B** Tracks for more distant rain. **C** Cycle of raindrops hitting the ground. **D** Shaking a wet brush: 1 and 2, the brush moves to the right; 3 and 4, the brush moves to the left and water continues to the right. **E** Tracks for a foreground snow cycle. **F** Tracks for a middle distance snow cycle. A distant level would be needed below this on long shots, etc.

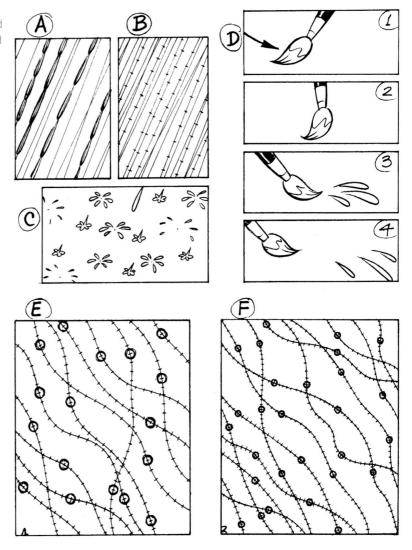

with a more random slope if a realistic effect is to be achieved. It is best to time it moving quickly down. If it is drawn on more than one level, the distant rain should move more slowly, to give depth. Foreground rain should cross the screen in about six frames whilst more distant rain should move progressively slower.

Individual drops are drawn as straight lines with consecutive drawings overlapping each other slightly. Rain almost certainly needs single frame animation for a realistic effect. It also needs a fairly long repeat if it is not to appear too mechanical—24 frames at least.

For really heavy rain, the effect is enhanced by animating a cycle of drops hitting the ground. These can be quite random and unrelated to the falling rain. Each drop should animate out in about six frames.

As with all effects animation, rain can express a mood by its timing. For a miserable mood, rain can fall vertically at perhaps half its normal speed, whilst the speed can increase with a greater tilt from the horizontal for more violent moods.

A really stormy effect would need to show random gusts of wind and would be very difficult and time-consuming to animate.

Water Drops

When shaking water drops from a brush, for example, the drops should start one drawing later than the extreme of the brush, traveling in a continuation of the direction of the brush before the flick. In other words, before the flick the brush and water are traveling together, after the flick the brush changes direction, but the water keeps going.

Snow

Gently falling snow drifts in wavy lines and needs even longer cycles than rain to avoid the audience noticing the same flake following itself down the same track. Two seconds may be too short if the repeat is run more than a few times. A foreground flake may take about two seconds to cross the screen, but of course may take less.

To give depth to the snowfall, at least three different sizes of flake are usually needed; the smaller more distant ones traveling more slowly than those in the foreground. Distant snow is not generally animated out of the bottom of the screen but fizzles out in a random way somewhere on the screen. The exact point where it disappears depends on the background on which it is used.

Snow is usually produced by the animator providing a drawing of the wavy tracks of the snow, with graduations marked on them and numbered so that the snow can be traced directly onto cel, usually with a drybrush. Blizzards present a similar problem to rainstorms—the tracks become more horizontal as the wind speed increases—and a real storm effect calls for eddies and surges in the movement.

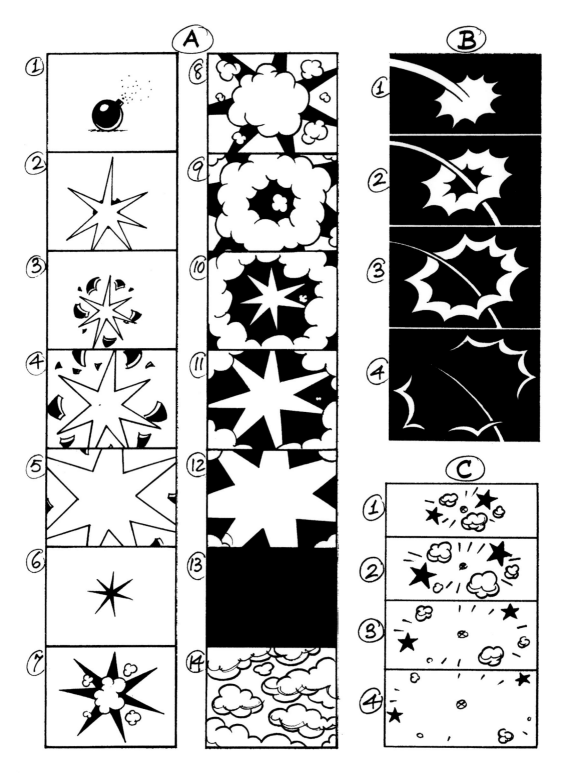

Explosions

As explosions are intended to shock the audience, it is not advisable to use a predictable formula for them. There are many different ways of creating the effect of an explosion, but there is some similarity in the timing in each case. There should be a quick anticipation of some sort, then a quick burst or series of bursts, which should be kept going for some frames, followed by a slower dispersal.

Explosions, therefore, start with a very fast movement and taper off to a slow finish. As the initial burst is so quick, a short anticipation, which attracts the eye to the point of explosion just before it happens, increases the effect. Four or five frames should be enough for this.

Once the explosion starts it should fill the screen in perhaps three frames, followed by a flicker effect for about six frames and then a slow clearance of smoke lasting several seconds.

A small bang, such as a pistol shot, can finish in perhaps five frames, but a larger explosion needs extending in time to be effective. A really impressive explosion, such as a long shot of a building blowing up, probably needs the burst itself to last for a second or more, perhaps by arranging a succession of secondary explosions within the main one. This also would require a slow aftermath with perhaps a column of smoke rising, and so on.

Smaller effects, which work on similar lines to explosions, are called 'splats'. These animate out in about five frames from the point of contact of a blow to emphasize the impact. They are usually painted white. To emphasize a lesser impact, one can animate out short radiating lines for about the same number of frames. Door slams can be emphasized either with a splat or with a number of radiating puffs of dust from the edges of the door. These also should disappear in about five frames.

FIGURE 47 **A** 1–14: a possible explosion. Drawing 2 is a quick anticipation followed by multiple bursts, which could be alternated with black-and-white frames. After drawing 14 the dust would slowly disperse. **B** A specimen 'splat'. **C** Dust, stars, radiating lines, etc. can be used to emphasize an impact.

Digital Effects

The creation of animated effects by computer has become a widely used tool in many major live action movies as well as cartoon films. Effects that were difficult or time-consuming to draw traditionally, like cast shadows or registering animated characters to live action backgrounds, are now done painlessly on the computer. During the early development of digital effects animation, the emphasis was on making the effects look as realistic as possible. Technicians made great strides in writing the mathematical formulas (algorithms), manipulating patterns of particles and fractals (a fragmented geometric shape that can be subdivided into parts, each part a reduced copy of the whole) to achieve natural-looking fire, smoke and water. Many good effects programs are available today commercially. These are called 'off-the-shelf software', as opposed to a studio developing proprietary programs for their specific needs.

The animator must set the direction and the duration of the effect, introduce gravity and account for solid objects in the path of the effects. You also set the control for speed of the effect, size and turbulence. In digital effects the animator is not only thinking of movement, but now is concerned with the color, composition and the light integration. It is a process of playback and continual adjusting, using various controls on your computer screen. Despite the hyperbole of software salesmen and industry journalists, it is still a process that is formed frame-by-frame.

A great problem before 2001 was doing bottom-light effects digitally, i.e. the glow of a fire, a lightning bolt, or a laser beam. Motion picture film was a chemical emulsion coated on celluloid strips, so controlled overexposure in the camera burned the emulsion. That gave the fire its recognizable glow. Because you can't overexpose in a computer, a lot of thinking had to go into recreating that same diffusion of light. Today, known as 'glare effects', they have become the responsibility mainly of the compositor, although some effects animators do compositing themselves.

The *Aesthetic* in Effects Animation

Many veteran effects animators complain that the copying of natural effects is not the end-all in effects in animation. There is an *aesthetic* to drawn effects that must be taken into account.

What if your fire is highly stylized like the Japanese prints of Hokusai? In Nina Paley's 2008 film *Sita Sings the Blues*, she styled her fire after Indian classical painting. Beyond the basic design style to the effects, you must also take into account the temper of the movement. Effects can have emotions, too. What if you want the fire to be angry? Or you want happy, lapping waters? Perhaps the director wants the lightning bolts to have more branches and linger on screen longer? These are supra-natural concepts that need to be manipulated by the artistic taste of the effects animator.

Just as computerized music went from adaptations of traditional music to sounds only made possible in the computer, so animated effects are leaving their insistence on photo-realism and going as abstract as the imagination dares to go.

For example, in the classic Japanese film *Spirited Away* by Hayao Miyazaki, there is the scene where the little girl is reaching into a rushing deluge of water to untangle the mud monster. While she is speaking dialog with her face close to the torrent, the animator deliberately chose to underplay the water spraying around her head so that the audience could see her expression clearly, i.e. her eyes wide open. In reality, the force of that torrent would spray so fiercely in her face that she could never have been able to speak clearly, much less keep her eyes open. Yet, we as an audience do not question the reality of the scene.

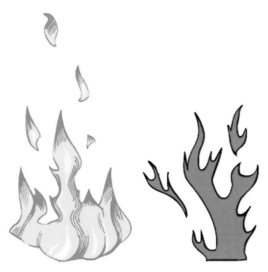

FIGURE 48 Different types of designs for fire effects.

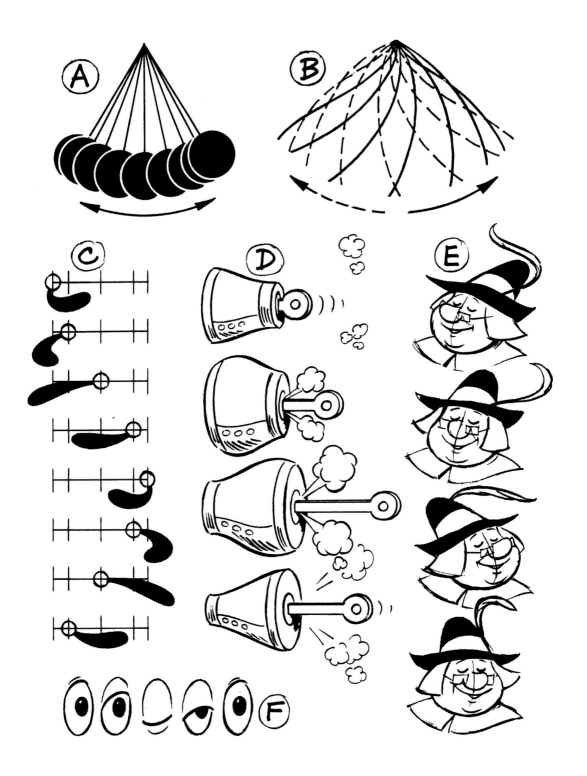

Repeat Movements of Inanimate Objects

In straightforward to-and-fro movements, such as those of a piston or pendulum, it may or may not be possible to use the same drawings in the reverse order for the return movement. With a rigid pendulum (Fig. A) it would be possible, but with a cartoon piston (Fig. D) animated with steam pressure in mind, the drawings used for the forward movement would not work in reverse.

In any flexible movement, or that of any object which has something trailing, then a fresh set of inbetweens must be done for the two directions of movement (Figs B, C and E).

In a to-and-fro movement in which the same drawings can be used in reverse, an optical problem arises at the ends of the movements. Suppose the animation is done on double frames and charted: 1, 2, 3, 4, 5, 6, 5, 4, 3, 2, 1, 2, 3..., etc. it will be seen that drawings 5 and 2 occur twice, that is, they are on the screen for four frames out of six and so make a greater impact on the eye than the actual extremes, which in this case are 1 and 6. This effect can be avoided either by holding drawings 1 and 6 for four frames each, or else by missing out one of the exposures on 5 and 2, thus: 1, 2, 3, 4, 6, 5, 4, 3, 1, 2, 3... etc.

A similar optical effect can occur with eye blinks if the same inbetweens are used on the way down as on the way up, especially in close ups. In this case it is better to space the two sets of inbetweens differently so that the same positions do not occur on both the opening and shutting movements.

FIGURE 49 **A** A straightforward swing cycle, in which the same drawings can be used for both directions of swing. **B** Flexible objects tend to swing more like this. **C**, **D** and **E** Short repeat cycles in which the same inbetweens cannot be used in both directions of movement. **F** An eye blink.

Timing a Walk

What are the main features of a 'normal' human walk? There can be as many walks as there are people. Does the character walk leaning forward or laid-back? With slumped shoulders or a posture that is ramrod erect? Does the character walk on tiptoes or on the balls of their feet or heels? Nose in the air or head down, deep in thought? What are the arms doing?

The walk is the first step to finding the key to a character's personality.

To begin, walking has been described by the old animators as 'controlled falling', i.e. skilled manipulation of balance and weight. Most animators begin by animating their own walk, since it's motion is already within their minds.

The only point in a walk when the figure is in balance is at the instant when the heel of the front foot touches the ground; the body weight here is evenly spaced between the two feet. This is usually the main key drawing (Fig. A). It gives the stride length, and so can be used for planning the number of steps needed for the character to cover a certain distance. This 'step' position is the one with the maximum forward and backward swing of the arms. It is actually the middle of the fall forward onto the front foot, when the front knee bends to cushion the downward movement of the weight. The key position here is usually known as the 'squash' position (Fig. A5). The body's center of gravity is at its lowest point, and the front leg supports the body weight. The back foot is almost vertical and although the toe is just touching the ground, it bears no weight at all in this position. In Fig. A9 the bent leg straightens, lifting the center of gravity to its highest point as the back foot moves forward. This is the 'up' position and leads into the next 'step' at 13.

There are two slightly different ways of animating a walk—the choice is one of convenience. Suppose a character makes a 1.8 inch stride in 12 frames. Assuming that the walk is a repeat movement, then if we call the left 'step' drawing 1, this drawing will appear again 24 frames later (i.e. drawing 25 = drawing 1) 3.6 inches left or right of the original position (Fig. B).

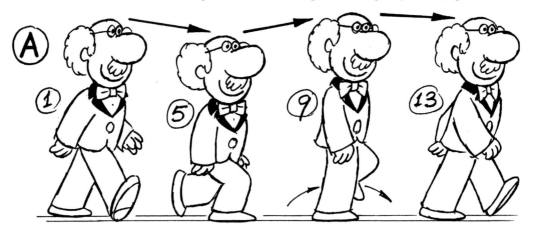

So the intermediate positions of the walk can be animated between these two positions. The character can then advance along the cels, relative to the pegs, until it arrives back at drawing 1 at which point the pegs are moved 3.6 inches and carry on for the next two steps.

The alternative method (Fig. C) is to animate from drawing 1 back to drawing 1 in the same position, so that all the bodies in the cycle are superimposed over one another, with an up-and-down movement only, instead of advancing along the cels. The 3.6 inches, which the figure moves along every two paces, is now taken up by moving the foot backward 0.15 inch per frame. After 24 frames the feet have effectively slid back the 3.6 inches to make up the two steps. This is called 'animating on the spot' because to make a man walk by this method, the pegs carrying the figure remain static while the background pans backward by the same amount as the feet per frame.

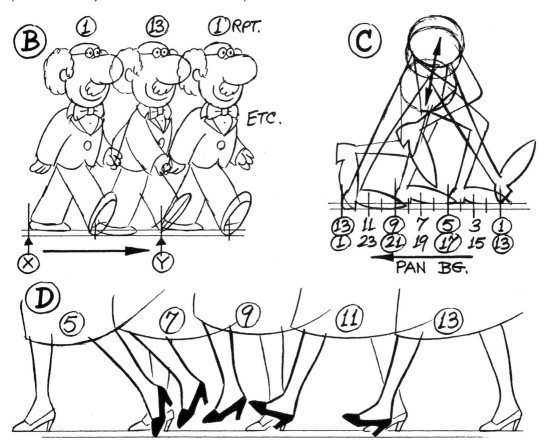

FIGURE 50 **A** Part of a walk cycle, spread out for clarity. The complete cycle would be 1–23 (i.e. 1 = 25), 17 being the same as 5 with legs reversed, and 21 the same as 9. **B** The same cycle animated forward with static pegs. The pegs stay in position X whilst the figure moves forward on 1–23. The pegs then move to the right by the length of two strides and 1–23 is repeated in the new position Y. **C** A walk cycle 'on the spot'. The body moves up and down whilst the heels slide backward along the scales at the same speed as the background pan. **D** Successive positions in a naturalistic walk. The left shoe is shaded black. Note that on 11 the left leg is straight just before making contact with the ground on 13 (see next page).

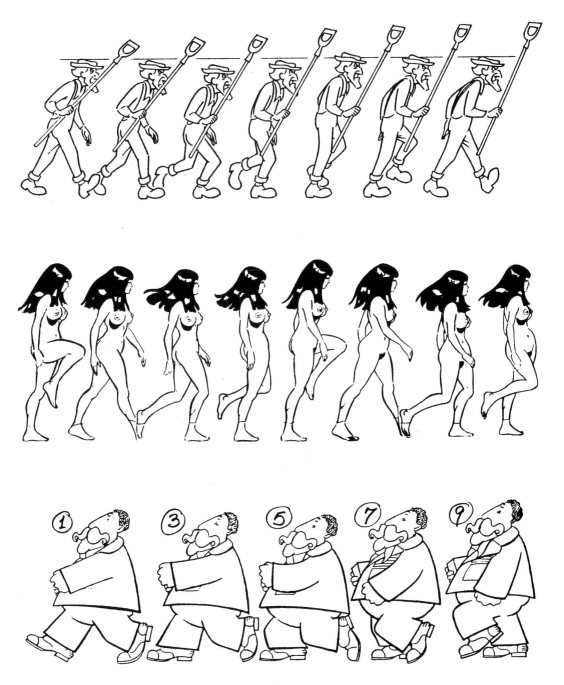

Types of Walk

The up-and-down movement of the body should slow in and out of the key positions, but the forward movement of the body should be at a uniform speed, or the animation 'sticks'.

It is important that there is just enough time for the straight leg to register on the screen in the 'step' position. As the front leg is bent both before and after this position, there is a danger that the eye will connect these two positions—missing the straight leg—with the effect that the character is doing a 'bent-leg' walk. Fig. D on the previous page gives another variation of this problem. It is based on a naturalistic walk, and the left leg kicks out straight on drawing 11, although it is still moving forward to the 'step' position 13. The front foot should slap down flat on to the ground quickly after the 'step' drawing. This loosens the ankle joint.

There are many variations on this walk. For example, in an aggressive walk the body leans forward, the chin is out, and the fists are clenched. In a proud or pompous walk the body may lean slightly backward, with the chest out and plenty of shoulder action, with the highest position on the 'step' drawing. In a tired walk the body and head droop, arms may hang loosely and the feet may drag along the ground, and so on. A double bounce walk can give a character the sense of youthful energy, a 'street-sense' feel, like a tough gang member. To achieve this, on each straight up pose add two additional frames of the character's foot rising up on its toe, almost a small hop. This bouncing gait creates a natural swagger for the character that shows 'attitude'.

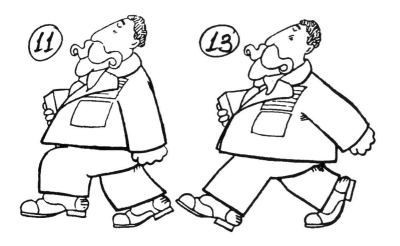

FIGURE 51 Three different styles of walk: **Top** One step (12 frames) of a 24 frame cycle. **Middle** Key positions from a 48 frame walk through deep snow. On double frames two inbetweens are needed between each pair of keys. **Bottom** One stride of a 24 frame cycle on double frames. The two 'step' positions are drawings 1 and 13. The weight of the body squashes onto the front foot on 5 and rises as the back foot comes forward on 9. Note how the front leg remains straight on 3 to avoid the 'bent leg' look.

Spacing of Drawings in Perspective Animation

To animate in true perspective requires complex draughtsmanship and some understanding of the geometrical treatment of the subject.

Especially when a character walks in perspective, an accurate perspective grid must be drawn giving the height of the character and the length of the strides, so that the animator has a clear idea of how the spacing of the strides gradually increases or decreases. It is quite a difficult animation problem to make all parts of a figure get larger or smaller and yet remain in the right proportions.

For dramatic effect when a character rushes toward or away from the camera, a low horizon is preferable. High horizons provide a more relaxed effect. In both instances the vanishing point must be established in relationship to the horizon, which represents the camera or the audience's eye level. The increasing or decreasing lengths of strides must be worked out by defining measuring points for every few drawings. Estimation is possible, but must be plotted out carefully.

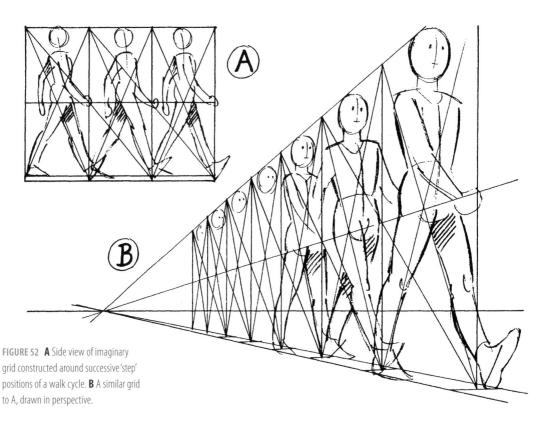

FIGURE 52 **A** Side view of imaginary grid constructed around successive 'step' positions of a walk cycle. **B** A similar grid to A, drawn in perspective.

Variation in perspective can be achieved by lowering the horizon and changing the vanishing point during animation. This, however, requires some experience. Weight must be evident in all perspective animation. In a perspective shot, a character can run from the foreground over the horizon in a few frames, approximately 12 to 16, provided the right degree of 'anticipation' is given. Because of the speed of the action, it is better to use single frame animation.

Effective animation requires movement in space and an illusion of three dimensions, otherwise the characters may appear to be too flat. Take advantage where possible of opportunities for movement in exaggerated perspective. For instance, if some part of a figure or object swings round close to the camera, emphasize the increase in size in the drawings.

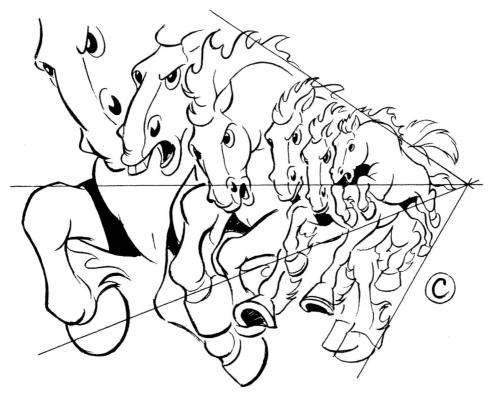

C A rapid perspective gallop. There was one drawing in between each pair of positions.

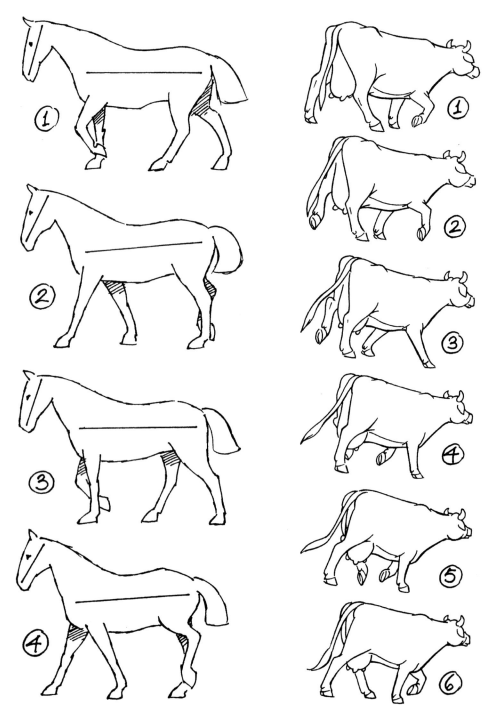

FIGURE 53 In a normal walk, a horse's front legs step half a pace later than the back legs. The body and head tilt slightly as a result of the alternate stepping of the back and front legs. On the right, a cow walking, from *Animal Farm*.

Timing Animals' Movements

Horses

The order in which the feet of a horse touch the ground is: back left, front left, back right, front right, back left, front left, back right, front right, etc.

A horse normally takes about a second to make one complete stride, i.e. from 'back left' to 'back left'. If it is walking freely the feet touch the ground at equal intervals of time.

If 24 frames are taken as the length of a walk cycle, i.e. back left hits the ground on frame 1, 'back right' hits the ground on frame 13, and 'front left' and 'front right' hit the ground on frames 7 and 19 respectively.

In the step position on the back legs, on frames 1 and 13, the back legs form two sides of a triangle. The rump is lower than it is on frames 7 and 19, where one leg is vertical as the other one passes it. The shoulders are lower on frames 7 and 19 than they are on frames 1 and 13 for the same reason. This causes a slight rocking movement to the line of the horse's back. Also on the front step positions, as the shoulders go down, the head is pulled into a slightly more horizontal slant than it is on frames 1 and 13.

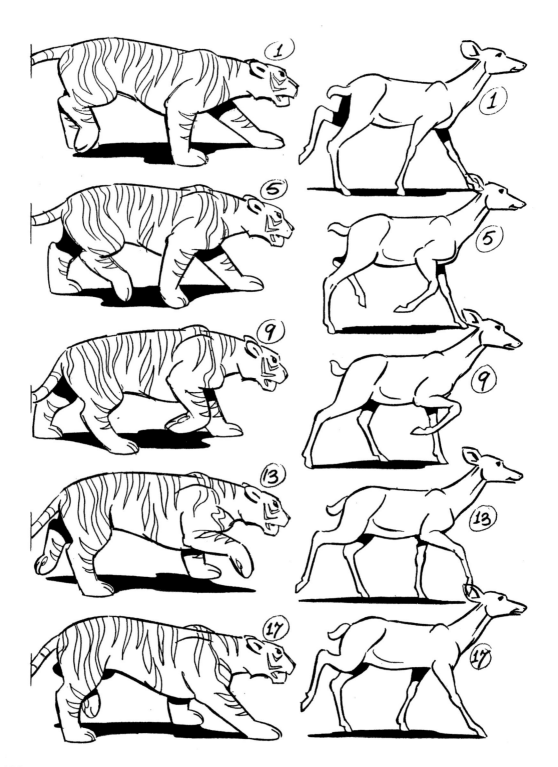

Other Quadrupeds

Other quadrupeds, like cows, are surprisingly similar in the timing of their walk to a horse. The order of the feet is usually the same and the movements of the back and the head follow the same pattern.

An elephant may take a second or perhaps a second and a half to make a complete stride, whilst a smaller animal such as a cat may take a complete stride in half a second or less, although these timings may vary greatly.

Some animals, such as the deer family, lift their feet high when walking; cats also do this when stalking. There is no equivalent of the 'squash' position of a human walk in a four-footed walk, as the back foot of each pair usually comes off the ground immediately the front foot is on the ground.

Predators of the cat family (lions, cougars, housecats) possess a more flexible dorsal construction in their spine. This gives their motion a wiry grace and the ability to change direction very rapidly. Because felines have more of a radius bone in their front forelegs than dogs or cows, they can turn their paws inward (pronator-supernator action).

A walking animal spends roughly half the time supported by two legs and the other half supported by three. A four-footed animal starting a walk usually starts with one of its back legs, followed by the front leg on the same side.

FIGURE 54 Parts of cycles of a tiger and a deer walking. In both cycles drawing 17 has the opposite feet positions to drawing 1, so the complete repeat would take 32 frames. Although the length of stride is the same in both these examples, note the difference in feeling. The tiger has a crouched menacing attitude, whilst the exaggerated lift of the legs helps the deer's motion to be bouncy and light.

Timing an Animal's Gallop

A horse increases its speed from a walk, to a trot, then a canter and finally to a gallop, at which it travels at maximum speed.

In the gallop a complete stride takes about half a second, and the order in which the feet hit the ground is: back left, back right, front left, front right—pause—back left, back right, front left, front right, etc. The back legs make the same movement as each other with a slight time lag and the same happens with the front feet. The big push is given by the front feet and after this push the animal becomes momentarily airborne.

In some animals, for instance the cat, the bigger push comes from the back legs and the cat becomes airborne after this movement. The shoulders and rump rise and fall giving a rocking movement to the line of the back, and the head is tilted at a slightly more horizontal angle as the shoulders go down

FIGURE 55 The flexibility of the pastern or wrist joint of a quadruped during a gallop is particularly noticeable. This joint can bend backward into almost a right angle as it takes the weight of the animal (drawings 1 and 7), and can also bend into almost a right angle the other way when relaxed and the foot is in the air (drawings 2, 3, 5, etc.).

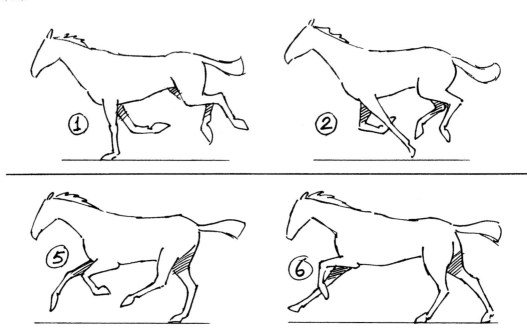

and the front legs take the weight. The spine itself also flexes and extends. This is very noticeable with a cat, as when the back legs come forward a pronounced hump appears in the lower half of the back, and as the back legs push the body into the spring, the spine stretches out into a reverse curve. The movement of the hip joint comes strongly into play in a gallop and the forward and backward movement of the thighs, combined with the bending and stretching of the spine, gives the impression that the animal's body is alternately lengthening and shortening. When the big leap comes from the back legs, as with a cat, the order of feet hitting the ground is: back left, back right—pause—front right, front left, back left, back right, etc. The complete stride of a cat takes about {1/3} second.

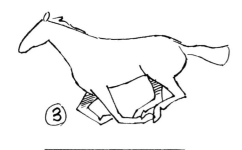

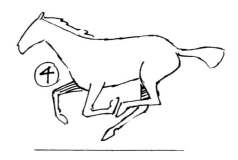

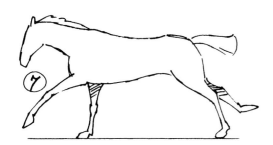

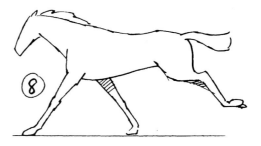

Bird Flight

Birds are well adapted to fast movement through the air. They are streamlined and waste the minimum amount of energy in the air. The body enhances the movement by lying in the direction of the airflow. The legs are tucked up or trailed in flight.

The aerodynamics of bird flight is very complex and it is unnecessary to go into detail. The power stroke is the downward stroke against the cushion of air beneath the bird, and during it the air resistance closes the feathers and the wing makes as large an area as possible, to maximize the thrust. Birds have very large chest muscles to power the downstroke. The muscles controlling the upstroke are much smaller, as the air resistance is much less. During this stroke the wing folds partially to present a smaller surface area and the feathers tend to separate like vanes to allow the air to pass between them. The body is usually tilted slightly upwards at the head, is lifted slightly during the downstroke and falls again during the upstroke.

In normal flight the wing strokes are not straight up and down. The direction of beat is slightly backward on the upstroke and slightly forwards on the downstroke. This is the opposite of what might be expected for forward flight, but the forward impetus is actually given by the tilt of the wing surfaces. This forward and backward wing beat is particularly noticeable when the bird is hovering (the body may be almost vertical and the wing beat almost horizontal) and also when the bird is rising or coming in to land.

During a flying cycle, the upstroke and the downstroke take about the same time although with larger birds at least, the downstroke is slower. The length of the repeat depends on the size of the bird. On the whole a large bird moves more slowly than a small one. For example, a sparrow may make 12 complete wing beats in a second, whilst a heron or a stork may make only two.

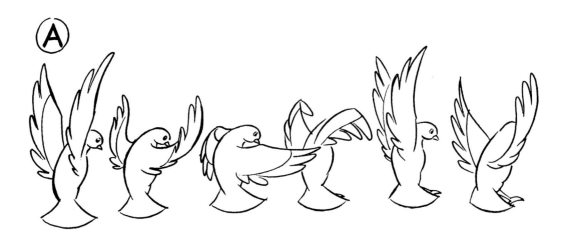

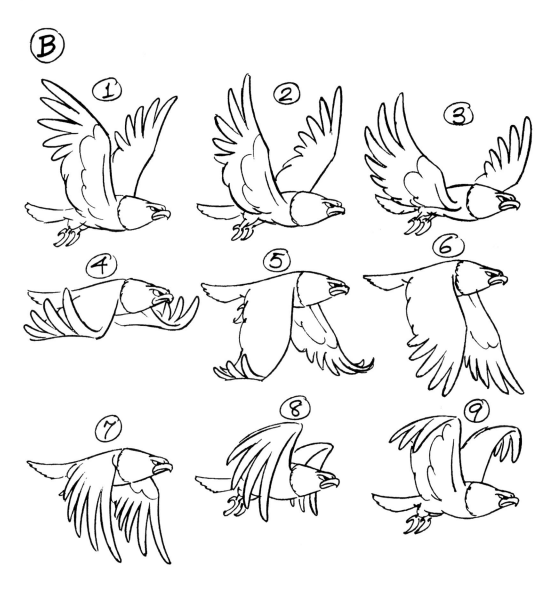

FIGURE 56 **A** A pigeon hovering as it comes in to land, from *Animal Farm*. Note the upright position of the body and the circling movement of the wings. **B** 1–9 is a repeat flying cycle. The body dips slightly in the air on 1 and rises slightly on 6 as the wings press downwards. The wingtip feathers radiate from the 'wrist' and trail backward in the direction they are coming from to give flexibility. Note how these feathers separate on the upstroke—7 and 8—to allow the air to pass between them.

Drybrush (Speed Lines) and Motion Blur

Drybrush (speed lines) and motion blur are ways an animator illustrates the optical blur the eye sees when an object is moving too rapidly to be seen clearly. In traditional animation, the speed line is a throwback with its origins in the graphic representations of rapid movement done in early newspaper cartoons. In later cartoons the speed line was replaced by drybrush.

This was a smeared drawing created by the cel painter by dabbing excess moisture from the paintbrush and streaking the character's colors in the direction of the line of movement. In digital animation the same effect is done by using the control that adds a motion blur. This effect creates a blur of the action similar to the blurry images of rapid action in live action photography.

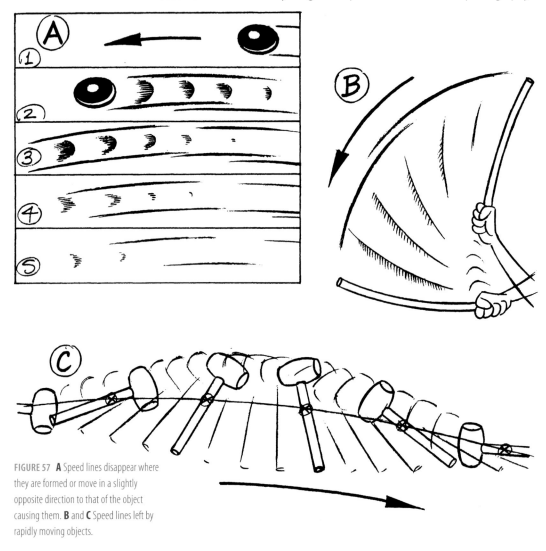

FIGURE 57 **A** Speed lines disappear where they are formed or move in a slightly opposite direction to that of the object causing them. **B** and **C** Speed lines left by rapidly moving objects.

While drybrush is an effect painted right onto the individual frames, the motion blur is an effect that is turned on in the computer. The motion blur does not appear in any single frame; it is always on and reveals how a character moves between frames. One may even want the blur to be visible, so it would match the well-known appearance of a live action film. This can be achieved by increasing the distance between the frames movement. Aesthetically, some still prefer the graphic approach of the speed line or drybrush, even in digital work. It remains a creative choice.

Drybrush (speed lines) should be timed quickly so that by the time the audience is aware of it, it is gone. Using drybrush for three frames is about the minimum effective length, but some spectacular examples can extend to 16 frames or more. The important factor to remember is that drybrush is something left behind by the object causing it. It must not move with the object as this gives the impression of threads attached to it.

If a stick swishes through the air and two consecutive drawings are widely spaced, the drybrush would consist of curves, carefully drawn in the direction of the swish, and a number of lines representing several in-between positions

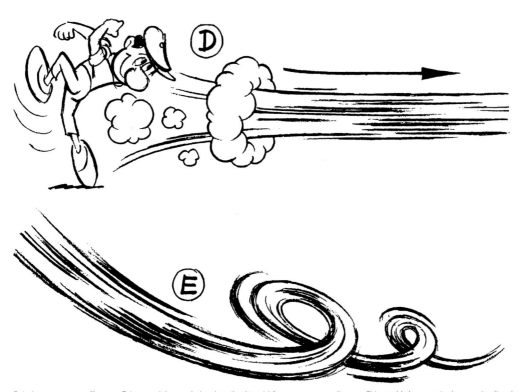

D A character zooms off screen. **E** A more elaborate drybrush trail, taking 16 frames or more to disperse. This would also move in the opposite direction to that of the character causing it.

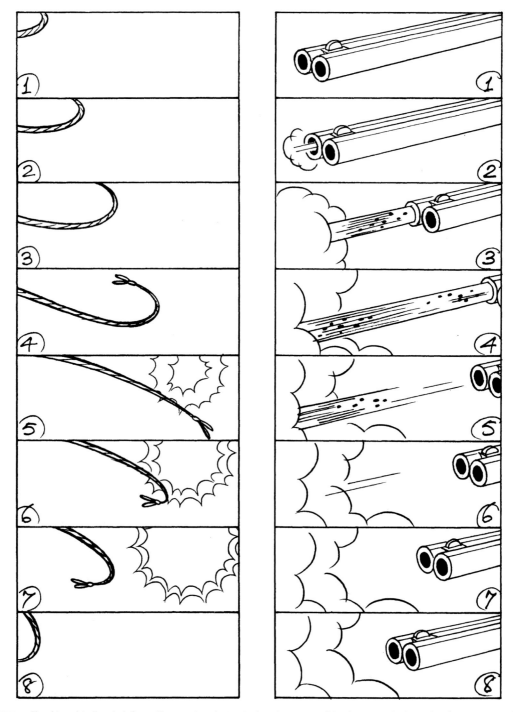

FIGURE 58 The whipcrack is all on single frames. The accent is on drawing 5, where the curvature of the whip reverses. In the gunshot, drawings 2, 3, 4 and 5 are single frames. 6 and 7 are double frames, with perhaps two or three more inbetweens slowing into the hold on 8. The accent is on drawing 4.

of the stick. These would all be put on cel in the color of the stick. On the next few drawings, this drybrush would be animated away (i.e. diminished to zero) in the same place as it originated, or moving very slightly in the opposite direction to the stick. In the meantime, further drybrush may have appeared. This would be animated out in the same way.

Drybrush should be used very sparingly and should be saved for situations where drawings are so widely spaced that the eye has difficulty in connecting them up. If the spacing of drawings is well done and fast action well anticipated, the eye accepts very widely spaced drawings without trouble.

A more spectacular drybrush effect might be used when a character runs off screen. For example, if a character is about to zip off right, he anticipates to the left, accelerates to the right and goes off very fast. This may not work without drawing in some drybrush streaks as he runs off, moving them rapidly to the left and following each other in a series of eddies. This can easily be continued for 16 frames or so, but must move rather quickly.

Accentuating a Movement

In order to emphasize a movement, the introduction of a visual effect is sometimes advisable. Such an effect does help to draw attention to the point the animator intends to make, especially if the movement is a quick one. The effect, however, must be a visual complement to the movement and should grow out of the type of action on the screen. It should also be quick and not labored, which could easily spoil the whole effect.

In the case of the fight sequence between the farmers and the animals in revolt in *Animal Farm* such extra effects were introduced to heighten the sequence's dramatic excitement.

The farmer's whipcrack, for example, was a sequence of eight drawings on single frames. At the accent of the movement, which was where the curvature of the whip reversed direction, a three frame, white 'crack' effect appeared (see page 114). The accent of the gunshot movement was where the gun barrel suddenly recoiled. The shot itself was made visible by a strong 'swish' effect followed by a slower puff of smoke as the gun barrel came forward again.

Since every situation is different, it is best to make any decisions about visual effects during the process of animation.

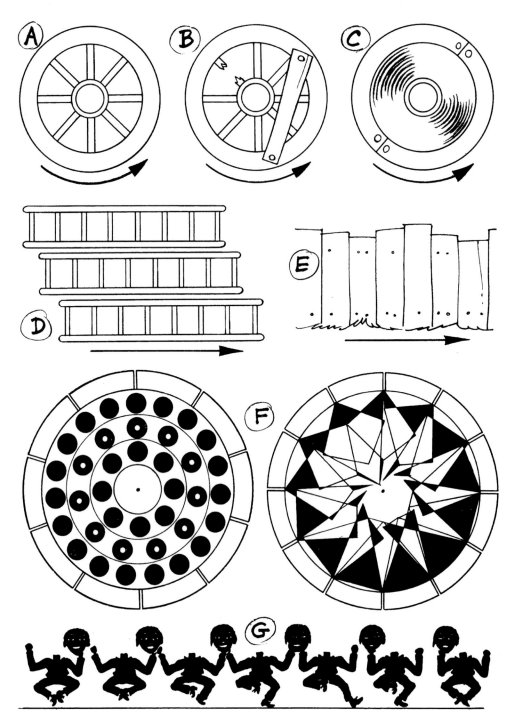

FIGURE 59 **A** This wheel cannot rotate in less than 20–24 frames. **B** This one can. **C** So can this. **D** This ladder is moving to the right, but the rungs will move to the left. **E** Beware of equally spaced vertical lines on panning backgrounds. **F** Two examples of stroboscope discs. **G** A zoetrope strip.

Strobing

Strobing is an effect which is an integral part of the mechanism of the cinema. Indeed the stroboscope, invented in 1832, was the first device used to present the illusion of a moving picture. The reflections of images on a spinning disc were viewed through slits around the edge of the disc so that a series of static images were seen in quick succession. A similar device, using the same principle, was the zoetrope in which paper strips were viewed through slits in a rotating cylinder.

Strobing is liable to occur in the movement of an object, which has a number of equally spaced similar elements. Some examples are the rungs of a ladder or the spokes of a wheel.

If a drawing of a ladder has rungs drawn 1 inch apart and the ladder starts to move along its length at an increasing speed, all is well until the amount of movement on the ladder is just under ½ inch. At this point the rungs begin to flicker and when the ladder moves up exactly ½ inch per frame, the movement is completely confused. This is because the eye sees a set of rungs on one frame and on the next frame it sees a set of rungs halfway between those on the first frame, and does not know whether the original rungs have moved to the right or to the left. On the next frame again, the rungs on the first frame have moved along 1 inch and so are superimposed over the rungs on the first frame. This gives the impression that the rungs are flickering on and off on alternate frames. If the movement is more than ½ inch, say 0.7 inches to the right, the eye jumps across the shorter gap and the rungs appear to move 0.3 inches to the left. This is the reason for the well-known illusion of stagecoach wheels appearing to turn backward.

The best cure for this strobing effect is to avoid situations where it may occur. The spokes of a wheel should be as widely spaced as possible. One time-honored solution is to have one broken spoke so that the gap can be seen rotating. Another way of overcoming this problem is to show the rim of the wheel rotating, but depict the spokes themselves as whizzing round with a drybrush effect.

A wheel, or ladder, always animates comfortably in the direction required if it moves by up to one third of the distance between one spoke, or rung, and the next. At faster speeds, if the broken rung dodge does not work, either avoid the sequence altogether, or work on it with drybrush to suggest the speed at which it is going.

Strobing can also occur on background pans (see opposite).

Fast Run Cycles

An eight frame run cycle—that is four frames to each step—gives a fast and vigorous dash. At this speed the successive leg positions are quite widely separated and may need drybrush or speed lines to make the movement flow. Drawing 5 shows the same position as drawing 1 but with opposite arms and feet. Similarly drawings 6 and 2, 7 and 3, and 8 and 4 show the same positions. These alternate positions should be varied slightly in each case, to avoid the rather mechanical effect of the same positions occurring every four frames.

A 12 frame cycle gives a less frantic run, but if the cycle is more than 16 frames the movement tends to lose its dash and appear too leisurely.

The body normally leans forward in the direction of movement, although for comic effect a backward lean can sometimes work. If a faster run than an eight frame repeat is needed, then perhaps several foot positions can be given on each drawing, to fill up the gaps in the movement, or possibly the legs can become a complete blur treated entirely in drybrush.

In the first example, drawing 4 is equivalent to the 'step' position in a walk, with the maximum forward and backward leg and arm movement. In a run it is also the point at which the centre of gravity of the body is farthest from the ground, that is, in mid-stride. In drawing 1 the weight is returning to its lowest point, which is in drawing 2. In drawing 3 the body starts to rise again as the thrust of the back foot gives the forward impetus for the next stride.

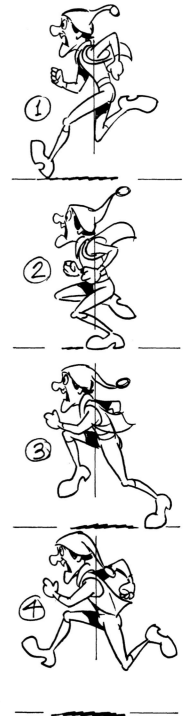

FIGURE 60 These are both examples of eight frame run cycles. This means four drawings to each step. Drawings 1 and 5 show the same leg and arm positions but with opposite feet and so do 2 and 6, 3 and 7, 4 and 8. In such a short cycle these positions should be varied slightly to avoid a mechanical effect.

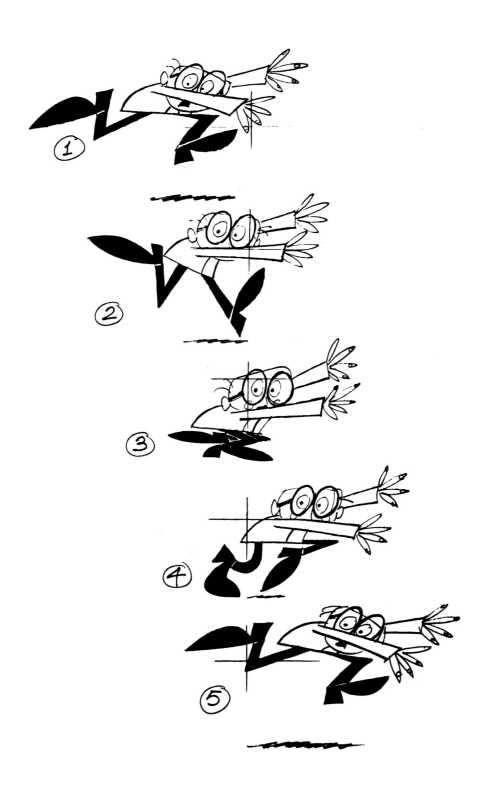

Characterization (Acting)

Character animation is the ultimate achievement of animation art. It is a complex combination of craftsmanship, mastery of the science of natural movement, acting and timing. When successful, it can feel to the animator like an Olympian moment of creation. The artist not only fulfills the needs of the performance as indicated by the script, but they are also responsible for the birth of an independent personality—a Bugs Bunny, Ariel the Little Mermaid or Bart Simpson. The characters' appeal is much more than just the voice actors' tones, the writers' wit, the animators' technique or the designers' style. They are the sum of all their parts. And when done successfully, the audience comes to know the character better than their own families and friends. You have it in your power to create memories that people will cherish for decades after.

FIGURE 61 Facial expression is an important part of characterization, but use the whole body to express feelings and emotions. The drawing of a character can be adapted to meet the needs of mood—in benevolent moments a character would be drawn in soft, curved lines; when more aggressive the drawing would become rather angular with more straight lines; when afraid he or she would shrink back and become more spiky, their hair standing on end, and so on.

Characterization in animation is concerned not so much with *what* the characters do, as *how* they do it. The old vaudeville (music hall) adage was 'It's not the opening of a door that is funny, it's when you open a door *funny*'. The audience is conditioned to look at human characters in human situations. In animation this can only be a starting point. The cartoon character should not behave exactly like a human being. It would feel and look wrong. Human reactions and human actions must be exaggerated, sometimes simplified, and distorted in order to achieve a dramatic or comic effect in cartoon. Good character animation is not merely the copying of life—it is the *caricature* of life, life plussed.

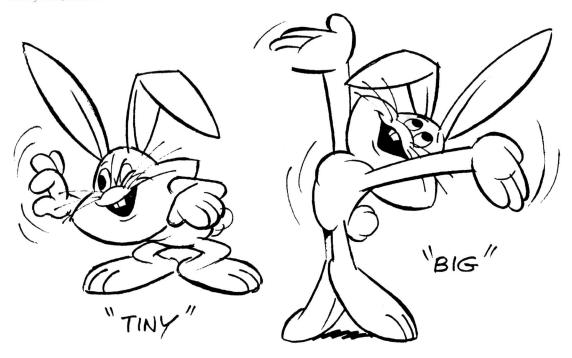

"TINY"

"BIG"

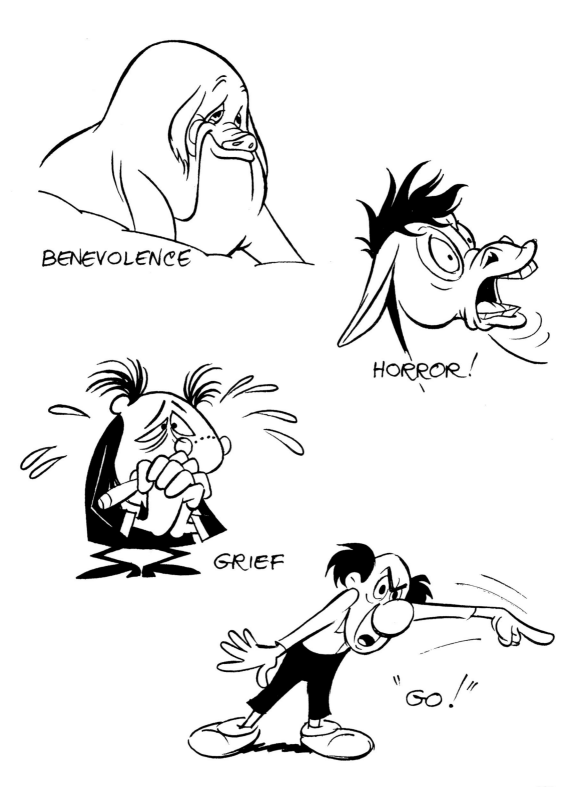

BENEVOLENCE

HORROR!

GRIEF

"GO!"

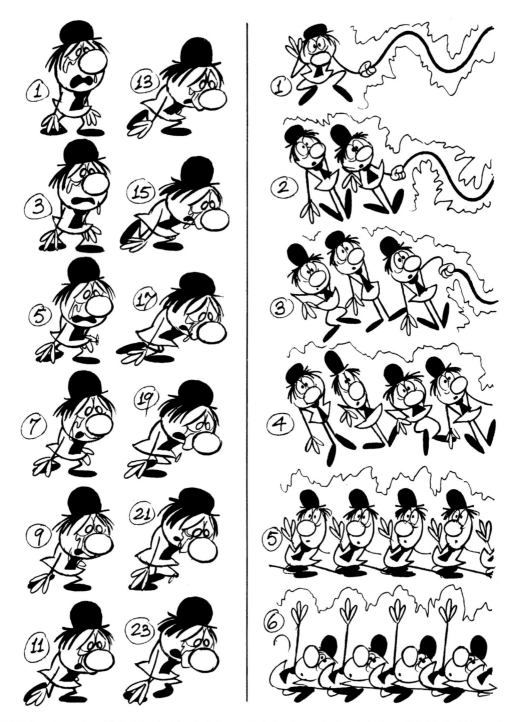

FIGURE 62 Two extremes of mood. On the left, animated on double frames, abject misery because the character has been rejected. On the right, general mayhem caused by the character being given a live electric plug to hold.

For these reasons the features of characters must be kept simple, allowing for maximum facial expression. The key positions should be sufficiently expressive, and held for a long enough period of time, to transmit the message to the audience. In animation, such transmission is easier in movement than in live action. When a movement is over-exaggerated it tends to create a sense of comedy. This is especially the case in fast movement. A deliberate exaggeration of speed, therefore, is the basis of timing for caricature as, for instance, in the case of *Tom and Jerry* cartoons. Slower pacing requires greater emphasis on expression and characterization of the subject. It requires more subtle animation, and it is infinitely more difficult to handle.

In the beginning we all animate ourselves, because we understand most intuitively how we would do actions and solve problems. Acting means to put ourselves into another's mind to see how they would solve problems. How would I move if I were a Sumo wrestler? A ballerina? A Wall Street tycoon? An elderly person leaning on a walker? Not only would all of these characters move in a different way, but even the *tempo* of their movements would be different. Some of the old Disney animators used to work with a piano teacher's metronome on their desks. This enabled them to assign a particular tempo to a planned animated character.

Many animators augment their animation training with some course in acting and/or mime. To expand their technique, animators also studied the same principles that great teachers such as Constantin Stanislavksy and Lee Strassberg wrote for flesh and blood actors. What we are doing on screen is in fact acting, except instead of using our bodies as our means of expression, we use our drawn characters.

The Use of Timing to Suggest Mood

The creation of mood is the stock-in-trade both of the cinema and the theater. It is also important in animated films but, as animation is a medium of exaggeration, it is advisable to avoid subtle shades of expression.

In general terms, the moods of depression, dejection, sorrow, etc. depend on slow timing for their effect, whilst the moods of elation, joy, triumph and so on depend on quicker timing. Other moods, such as wonder, puzzlement and suspicion may depend on facial expression and body posture. The aim is always, however, to convey to the audience the mental state of the character, and match this to the mood of the backgrounds, the camera movements, and everything else which contributes to the visual effect on the screen.

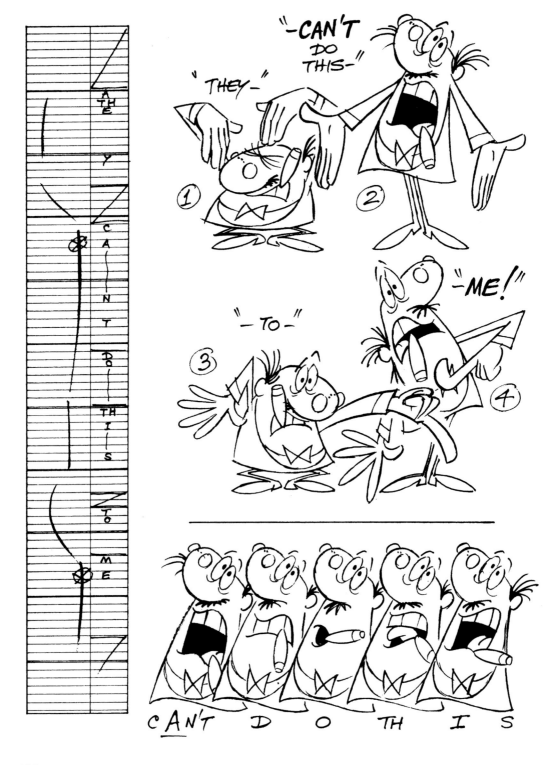

To express depression, the character must appear to have no energy. His body droops forwards, his head hangs on his chest, his knees sag, and his movements are slow, with frequent long holds and sighs. Anything that can be used in the drawing to convey the feeling of depression should be used—the hair and clothes hang limp, perhaps the hat sinks down over the ears, and the shoes squash with the extra weight of gloom.

Elation and joy, on the other hand, need plenty of energy, which gives quick, bouncy movements with the character frequently airborne. The body is upright or curving backward, with hair and clothing springy, and a general lightness of step.

Suspicion requires a deliberate expression of puzzlement and cannot be hurriedly timed. Give enough time for the audience to read the facial expression of the character and animate his hands for further emphasis if there is time.

Synchronizing Animation to Speech

Unlike live action films, where the dialog is simultaneously recorded with the action, in animation it must be recorded beforehand so that the movement can be fitted to it precisely. It is an essential pre-production operation, which cannot be left until after the completion of animation.

Once the soundtrack is available (either on tape or digital file), the type and character of the voice can be analyzed through the use of a synchronizer (16 mm or 35 mm) and a frame-by-frame timing guide for the animation can be made. This can be done either on the exposure chart, where there is a special column for it, or on a separate chart. In either case, it must be done in terms of frame analysis. No two dialog performances are the same. Even single words like 'you', 'yes', 'no', 'its', 'had' can vary substantially when analyzed in terms of separate frames. Such information is the basis of fitting animation to sound.

Firstly, listen carefully to the soundtrack and in particular to the feeling behind the way in which the words are spoken. Then listen to the phrasing and rhythm of the speech and find the positions of the main emphasis and key words. Then plan the movements of the character's body, head, arms, etc. to fit the words and the way in which they are being said, to reinforce the dramatic effect. Try to emphasize the main points of the speech with the whole body, if time and budget permit it. In animation, the meaning of dialog should be somewhat overemphasized, especially in an entertainment film.

FIGURE 63 An emotional impresario speaks the line: 'They can't do this to me!' The broken, wavy line on the phonetic breakdown strip represents the pitch and volume of the voice. The important accents in the soundtrack are on 'can't' and 'me' so the pattern of movement should emphasize the vowels in these two words.

Lip-Sync—1

In full animation, it is important for a character to mime. When speaking, therefore, their miming must be accurately synchronized to the soundtrack. Dialog is invariably recorded before production and the timing of it is passed to the animator as a phonetic breakdown. It is also important that the animator has a copy of the track on tape, so that they can listen to it repeatedly until the pattern of emphasis, the rise and fall of the voice, etc. is clear in their mind. It is sometimes useful to indicate this alongside the phonetic breakdown by means of a line which moves left and right as the voice falls and rises, and becomes thicker and thinner according to the degree of emphasis. Usually the voice rises on important syllables or words and falls on less important ones.

FIGURE 64 A sequence of drawings in which the whole body is involved in lip-sync. After a preliminary loss of temper and intake of breath, the sergeant major shouts: 'That man there!' From *The Guardsman*, a Halas and Batchelor commercial for TV.

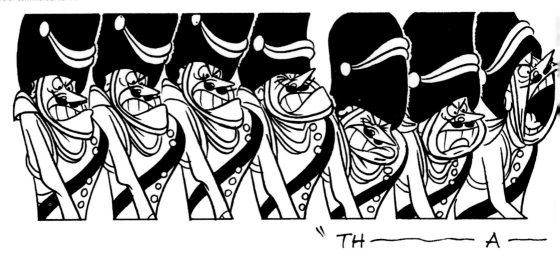

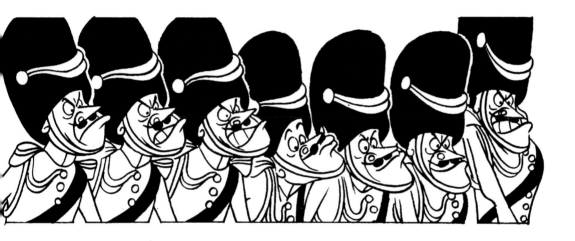

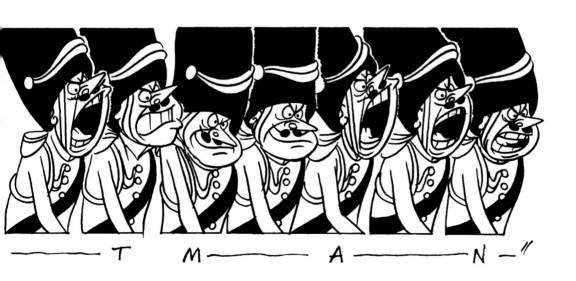

——— T ——— M ——— A ——— N —″

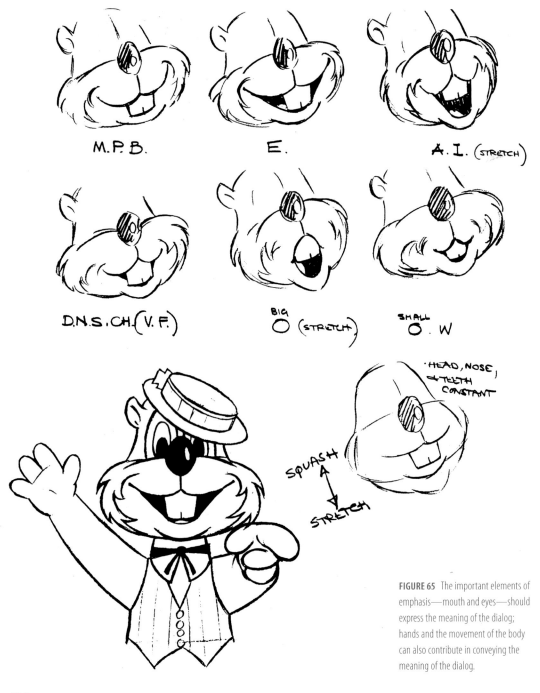

M.P.B.

E.

A.I. (STRETCH)

D.N.S.CH.(V.F.)

BIG
O (STRETCH)

SMALL
O . W

·HEAD, NOSE,
& TEETH
CONSTANT

SQUASH

STRETCH

FIGURE 65 The important elements of emphasis—mouth and eyes—should express the meaning of the dialog; hands and the movement of the body can also contribute in conveying the meaning of the dialog.

Lip-Sync—2

The first step is to make the character's actions fit his words. If he is aggressive he will tend to thrust himself forward and reinforce certain points with gestures. If he is shy he may shrink away and speak apologetically, and if he is crafty he may pretend to smile, whilst giving quick glances to see the reaction to his words, and so on.

The second step consists of moving the character's lips, and perhaps the lower part of the face, to fit the frame-by-frame phonetic breakdown of the speech on the exposure chart. Here it is important to listen repeatedly to the way the dialog is spoken. There is a broad tendency for the mouth and lower jaw to open on a vowel sound and close on a consonant. In a normally spoken sentence there are usually a few accentuated vowel sounds, and the rest of the words are of lesser importance. Play the soundtrack over and over again until the pattern of emphasis, the rise and fall of the voice, etc. is clear. Then plan the lip-sync to conform to this pattern in visual terms.

As already mentioned, in mass-produced TV series the dialog carries the central interest of the film and there is practically no animation, apart from the mouth. This is not acceptable in other types of production, and it is therefore important to ensure first of all that the mouth, eyes and other features of the face express the meaning of the dialog. The hands should also be used for emphasis. Thirdly, the body itself should be used to underline the content. The three elements have, of course, to be closely coordinated.

Lip-Sync—3

Once the basic timing of mouth movement is worked out, the next stage is to consider how the facial expression, head movement and body gestures can underline and add to the meaning and interest of the dialog.

In Old Major's first speech in *Animal Farm*, it was especially important to convey the message of this character to the audience, since the whole film was motivated by it. The facial expression had to show not only the figure's sincere concern but, as an ailing character, physical pain as well. The entire body of the pig was unanimated while it's face, eyes, mouth, snout and the facial creases conveyed the emotions of the character.

It is not essential to animate all vowels and consonants in terms of single frames. Especially in a TV entertainment series, where speed of production is essential, about eight positions of mouth and tongue are adequate.

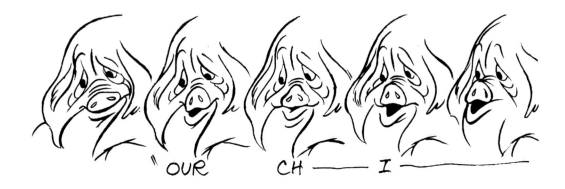

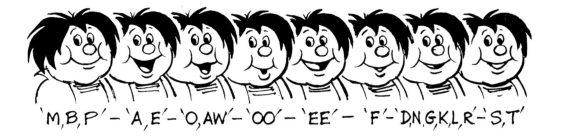

'M,B,P' – 'A,E' – 'O,AW' – 'OO' – 'EE' – 'F' – 'D,N,G,K,L,R' – 'S,T'

FIGURE 66 **Top** Eight mouth positions which, with a few inbetweens, would cover most lip-sync possibilities in limited animation. **Bottom** Lip-sync with full animation. The pig says: 'Our children are born...'

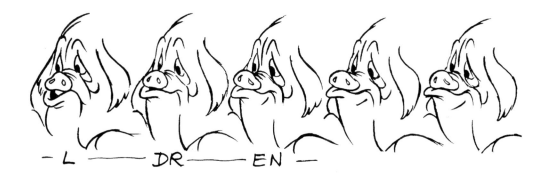

– L – DR – EN –

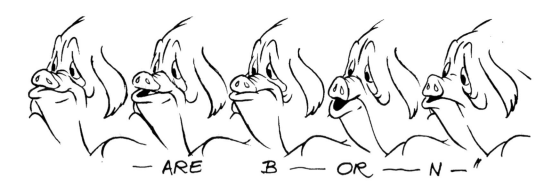

– ARE B – OR – N – "

Timing and Music

Ever since the very first animated productions, Disney's *Steamboat Mickey* and Oskar Fischinger's abstract film *Composition in Blue,* it has been clear that there is a strong relationship between animation and music. This relationship can be explained on two accounts. First, both elements have a basic mathematical foundation and move forward at a determined speed. Second, since animation is created manually frame-by-frame, it can be fitted to music in a very exact manner. It is further able to capture its rhythm, its mood and hit the beat right to the frame. Most animation makes good use of this advantage.

As a general principle it is more difficult to follow the rhythm of a musical composition with its mood than its beat. The latter aspect of the music is easily measured, since beats are fitted into bar units of defined time length and are interpreted in time units.

Bars can contain various numbers of beats and these must be measured to the film frame. Having done this, it is comparatively easy to fit the animation to the speed of the beat and find the right type of movement to follow the music, whether it is a slow waltz of 36 frames or four frames for rock music. A beat can be emphasized by synchronization of the feet but it works better if the whole body is used. In quick beats of three, four or six frames it is possible to follow every second beat without losing the rhythm. It is always better to work to specially prepared music if this can be afforded.

FIGURE 67 **A** This eight frame cycle, animated on double frames, of a whirling Spanish dancer is fitted closely to strong flamenco music. The figure fully conveys the character of the music with all its functional simplicity. **B** Single and double frame animation are alternated to fit the beats of the sound of a Spanish guitar. It is essential for the movement to follow the musical lead of a specially pre-recorded music track, for accurate synchronization.

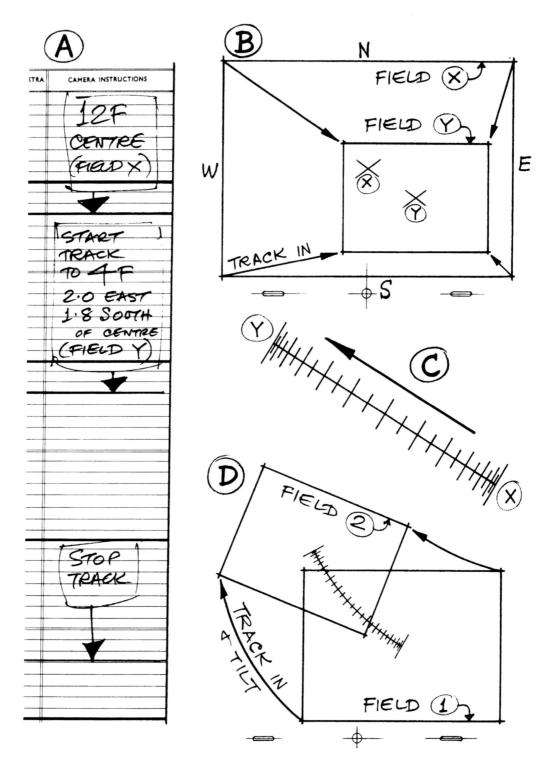

Traditional Camera Movements

Before the Digital Age all animation was shot on a down shooter camera, called at times a 'Rostrum camera' or an 'Oxberry camera', named after the American engineer John Oxberry (1918–1974) who designed an industry-standard camera stand. These cameras set-ups could be as simple as a home camera with a single frame shutter, clamped on a shelf or table, up to the huge, motorized two-column professional camera stands. But, in most cases, the set-up was similar: a single frame camera was mounted on a column and the animation artwork was placed on pegs on a compound table and held down by a heavy glass plate called a 'platen'. The table had long top and bottom peg bars to move (pan) artwork, could rotate 360 degrees (a 'tilt' angle) and was equipped with a light box underneath to do bottom-lit shots. The camera had an auto-focus so no matter how the camera or artwork moved, the lens adjusted. The earliest camera stands even had wooden frames, where camerapeople would pin artwork not in use.

Tracks ('Truck in' and 'Truck out' in the USA) are used to move into a closer field or pull back to a more distant one. This is done by moving the camera frame-by-frame, up or down its vertical pillar, above the animation drawings. Usually the field center also moves during a track and, as the camera travels on a fixed axis, this movement in a north–south, east–west direction is done by moving the table.

Tracks and table moves are worked out in terms of general timing—track lengths and the action which the various fields must include—preliminarily by the director on exposure sheets before production begins, then refined by a scene planner.

When the animator finalizes the action of the scene in detail, the scene planner converts the director's timing into specific instructions to the cameraperson. He or she writes down the field sizes and marks the frames where camera movements start and stop in the 'camera instructions' column on the exposure chart (Fig. A). They also provide a drawn field key with field centers marked (Fig. B).

It then becomes the cameraman's responsibility to execute the required move smoothly and accurately on the screen. Briefly, the procedure is as follows: in Fig. B the track is made from field X to field Y so the screen center moves towards the south-east. This means that under the camera, the table must move north-west. Fig. C is an enlargement of this table move, showing how the cameraperson divides the line to achieve a smooth movement from X to Y. At the same time they measure the distance the camera travels on its column during the track, and divide this in exactly the same way as Fig, C, so that camera and table top move smoothly together. Fig. D is a similar track and table move which includes a tilt. This would also be done as a table move.

Tracks and table moves are usually animated on single frames.

FIGURE 68 **A** The director's timing of tracks is finalized by the animator in the 'camera instructions' column on the exposure sheet. **B** The accompanying field key (layout). **C** Enlargement of field centers from Fig. B, inverted for use as table move. **D** Another example of a track including a table tilt.

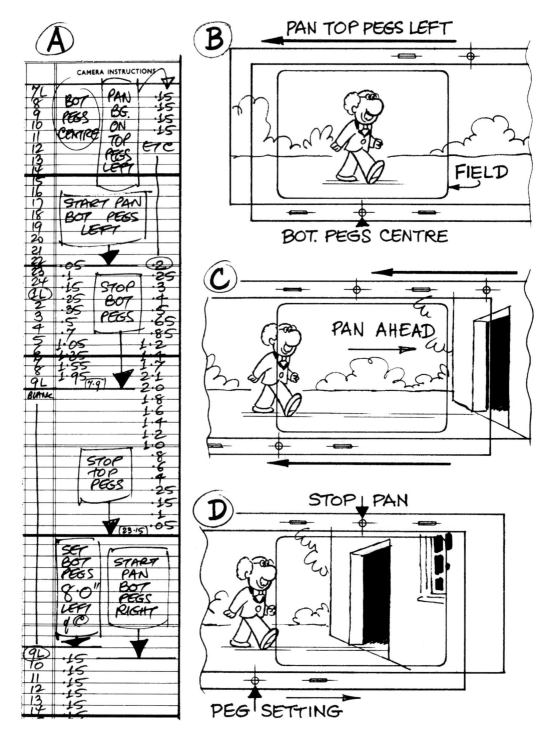

3D Camera Moves

The transition to computer technologies has greatly altered the job of creating camera moves in animation. Even in most traditionally animated-on-paper films, the down shooter camera stand has been replaced with a digital scanning system and elements painted digitally. In big budget 3D projects, all the animation is produced digitally, so a camera is no longer necessary. Artists planning camera moves no longer draw paper camera guides (drawn field key Fig. B on page 134), since the moves are blocked out virtually and tested in real time. Fig. C (on page 134), the movement track between fields X and Y, has been replaced with a virtual track on your computer screen called a 'path of action'. This is controlled with spline curves, which are bent to modify the shape, timing and acceleration of motion between the key positions.

In traditional paper animation, you moved artwork under a stationary camera, so to achieve a north-west move you moved the artwork on the table south-east. In digital animation, the virtual camera now moves around the subjects, much like a live action camera. Previously difficult tracking shots, like hand-held camera or racking the focus from foreground to background, can now be done with relative ease. In the past you had to describe the movement to the camera, now the camera describes itself to you by immediate playback.

In high-end Hollywood productions, the director oversees the creation of the storyboard as an animatic, with some perfunctory camera moves already laid in. The layout supervisor or pre-visualization director will plan out a rough camera pass—the virtual workbook. In some cases, a live action cinematographer (DP) or production designer would be invited to confer with the director about the positioning of the camera. As stated in the chapter on storyboarding, the rough layout pass has become more like a live action camera rehearsal with geometric avatars standing in for the actors.

As the animation is being done, the camera moves can be sweetened to better accommodate the performance. There is much more give and take than in the more departmentalized assembly lines of the past. Then, after animation is completed, the layout supervisor and director consult on a final camera pass. Since the animation is done in 3D, the director can change their mind to alter the camera angle radically without the artwork having to be redone. So something animated in a simple flat proscenium set-up can be rotated 90 degrees and made an upshot with an added fish-eye lens effect. All this can be done with little impact on the completed artwork. This last step is only done in 3D as in 2D some of the distortions and optical tricks accomplished in the drawings by the artist preclude a last minute change of camera angle.

FIGURE 69 **A** An example of peg movements written out by the animator in accordance with the director's timing. The walk cycle 1L–24L is on the left, and in the 'camera instructions' column the bottom peg moves are on the left in decimals of an inch, and the top peg moves are on the right. **B**, **C** and **D** show the positions of the top and bottom peg bars at the top, middle and bottom of Fig. A respectively.

Peg Movements in Traditional Animation

Unlike camera movements, Compensating Pan or Peg Bar moves are synched directly with the character animation levels, and therefore need to be calculated by the animator instead of being left for others. An example of a compensating pan for instance, is when a painted background stops panning at the speed with which the character stops walking and comes to a rest, or if a character gains momentum to go out of frame while the background stops. When an object or character is moving across a background there are very often two and sometimes more sets of pegs working together, and their compensating movements need to be worked out in great detail at the same time as the drawings.

In Figure 69, A is an example of peg instructions written out by the animator, and Figs B, C and D illustrate the timing problems involved.

In the left-hand column of Fig. A is a 24 frame walk cycle, 1L–24L. The character makes a 1.8 inch stride in 12 frames on bottom pegs. This governs the speed of background pan on top pegs to 0.15 inches per frame, Fig. B. The director then called for a 1 sec pan ahead to a doorway, which the character is approaching on the right of the background, Fig. C. The animator therefore measures the distance ahead to the door, and by trial and error splits this up into a series of accelerating and decelerating moves to stop smoothly at the door on the required frame. The character and the background must work together so that his feet do not slip (in effect the character moves 0.15 inches to the right of the background per frame, no matter what the background does). So the bottom pegs start to move to the left—always 0.15 inches per frame less than the top pegs. At some point this will bring the character off screen, when he is replaced with a blank cel. If we imagine him continuing to walk off screen, then on an appropriate frame he starts to appear in screen again. At this point the bottom pegs are set so that his front toe is just in screen, Fig. D. The bottom pegs then pan to the right 0.15 inches per frame against the static background.

The cycle 1L–24L would of course have to be on long cels with enough blank on the right of the character to pan him out of screen without the cel edge showing.

Peg Movements in 3D Animation

In digital 2D, whether created on paper and then scanned or drawn directly in a digital form, the peg bar or the notion of a peg bar is still the same. The main difference is that the peg bar is invisible to the camera, allowing for the animation to be scaled and positioned anywhere within the field of view. However, the basic structure laid out in the section 'Peg movements in traditional animation' remains the same.

3D animation has made such problems as compensating peg bar moves a moot point. When walking your character in 3D, they have a true position within the virtual set. The camera's path of action would be calculated in the rough layout pass, then played back and refined as the animation is created.

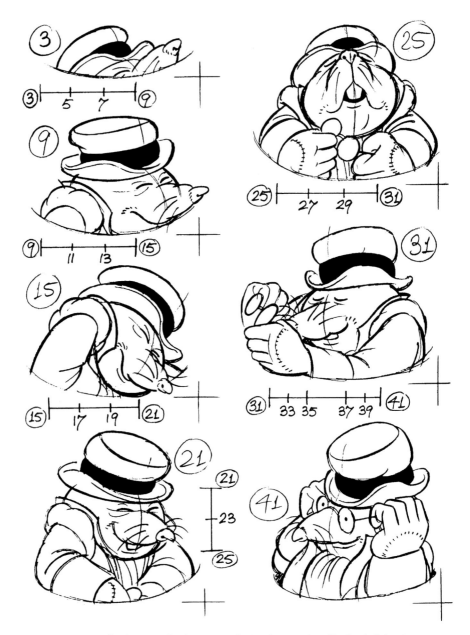

FIGURE 70 A sequence of key drawings with in-betweening scales. A mole squeezes himself up from his hole and puts on his spectacles, only to be stepped on a moment later Note the rounded feeling of all the shapes, to give him a non-aggressive, harmless look. From *Butterfly Ball* by Halas and Batchelor.

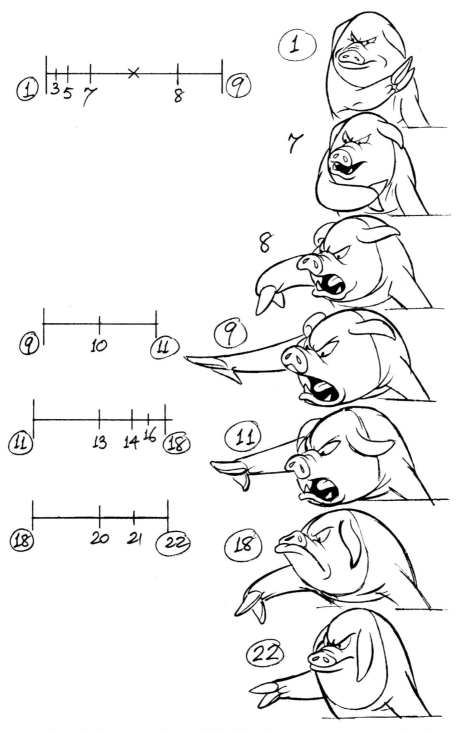

FIGURE 71 An example of an emphatic point (see page 44). Anticipation on 1, out to extreme on 9, back to pose on 18, and into final pose on 22.

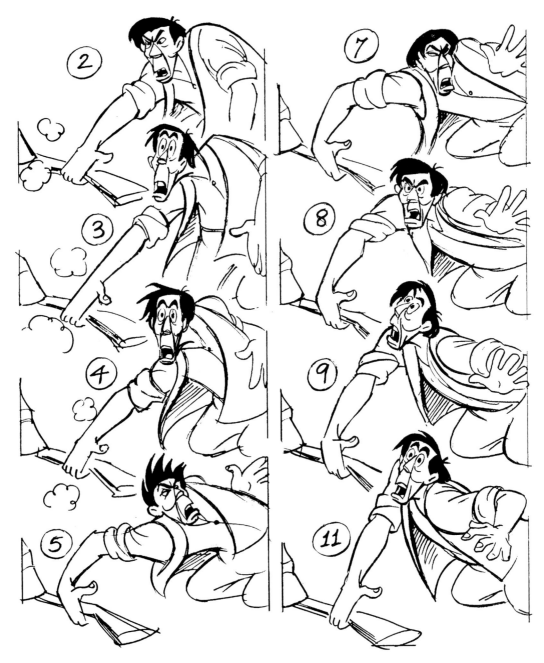

FIGURE 72 An example of a 'take'. Farmer Jones is about to pick up his shotgun when it is stepped on by Boxer, the horse, trapping Jones's fingers. He tries to pull his hand away on drawing 3, then, after a quick wriggle of pain on drawing 5, looks up in surprise at Boxer on drawing 11. (From *Animal Farm* by Halas and Batchelor.)

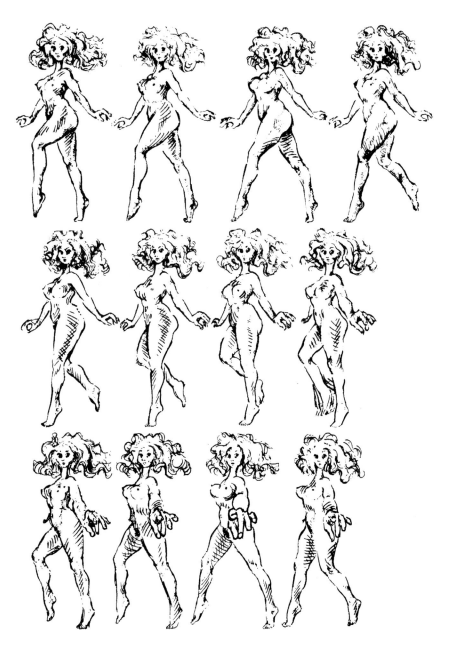

FIGURE 73 An example from Ryan Larkin's 1969 film *Walking* which was entirely devoted to the mechanics of animated walking cycles. This example represents a 32 frame double frame cycle demonstrating how smoothly it is possible to carry out an extremely difficult human movement. It also makes good use of perspective animation through the exaggeration of the character's arm nearest to the camera.

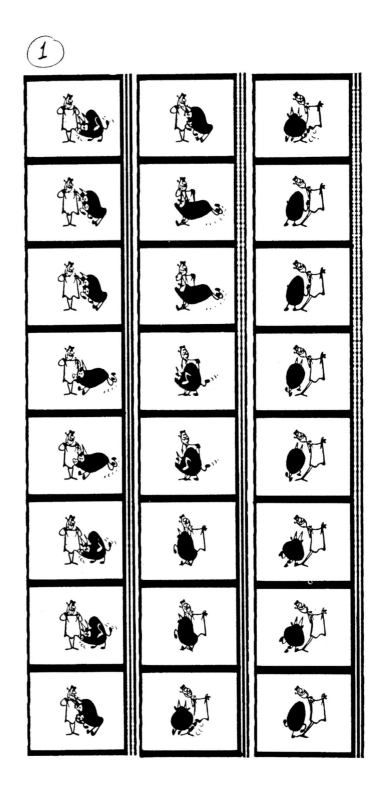

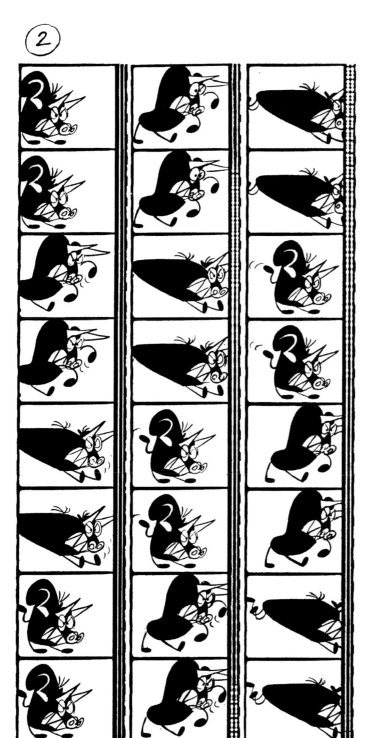

FIGURE 74 Animation samples enlarged from actual film frames show the timing of certain actions: **1** The Matador, in the film *The Insolent Matador*, fighting a furious bull. In spite of the high speed of this action, it is possible to animate in double frames. The economy of work could be considerable and the audience would not notice the difference in the smoothness of the action. **2** The bull charge in the film *The Insolent Matador*. Gesture and force of action convey the power and fury of this dangerous animal. Nevertheless, the action is conveyed in double frames and it loses none of its dynamism.

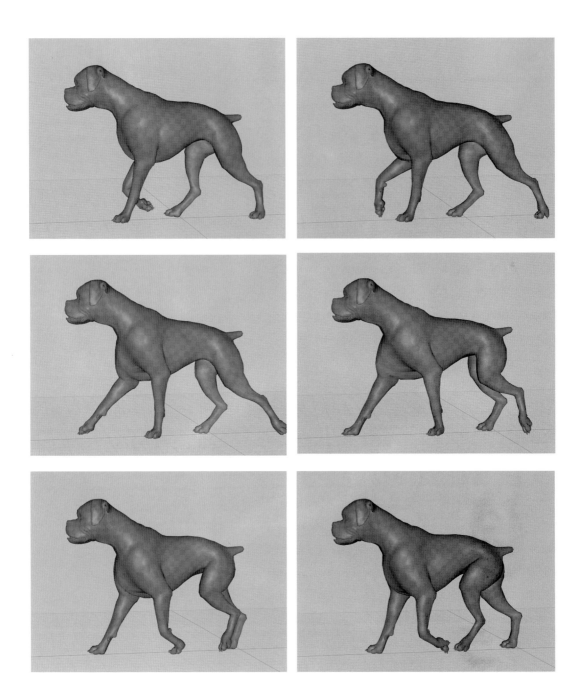

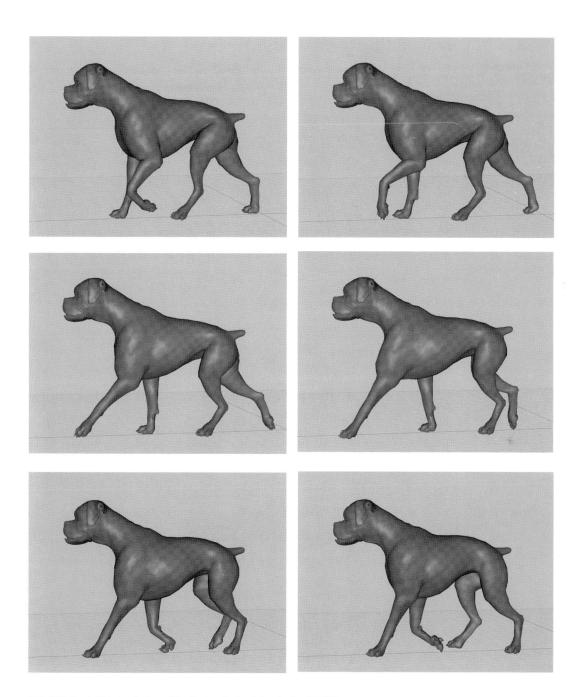

FIGURE 75 Rough 3D design of a dog walking. Courtesy Rhythm & Hues Studios. (©2008).

Editing Animation

Some like to think that because animated film is so carefully planned out in advance, the final editing becomes a simple task of stringing together shots. But in practice we find that the animated film can require the touch of an editing professional just as much as a live action film does. In addition, an editor possesses many more digital tricks to enhance the final film than they did in the age of guillotine splicers and tape. Most fades ('dissolves' in the USA) and wipes from one shot to another are now done in editorial. Editors can duplicate and flop shots, and even digitally correct small mistakes. Additionally, an editor is an artist in their own right, and they are sensitive to the overall pacing of the cuts and the overall timing of the film. After the work is done, there are many films that could still use a final tightening in editorial.

If your budget does not permit the hiring of an editor and their top-line equipment, new 2D and 3D software programs make desktop editing a simple task. But just be sensitive to the special challenges each type of project presents. You would not edit an online game for preschoolers like a violently paced feature film. Over the years, editing styles have changed. Since the rock & roll video era of the 1980s, audiences are much more tolerant of rapid cutting and jump cuts than previous generations. In the first decade of the twenty-first century, the audience's taste for 'reality' shows spun off an interest in a more free-floating camera, and a deliberate awkwardness to the camerawork—this all to duplicate a 'man-on-the-scene' home-made feel. The Sony Pictures 2007 film *Surf's Up* experimented with this to great effect. They animated and rendered their scenes the conventional way, then re-photographed the existing scenes with a separate camera to achieve the hand-held 'reality show' look. The 2008 Dreamworks Animation film *Kung Fu Panda* played with split screen images, sometimes having three separate scenes occurring up on the screen simultaneously.

Editing for Feature Films

Feature films are, for any company, a high stakes gamble, where all the stops are pulled to achieve the best cinematic experience possible. As taste in film changes with the times, so audiences expect animated films to keep pace. Animators should be open to experiment with new ideas in cutting, more interesting camera moves, and montages that challenge the normal idea of time and space. In the 1990s, Pixar adopted the custom used at Walt Disney years ago of trying out a new technique in a short first, then adapting what they learned into the feature projects.

Editing for Television Episodes

Episodic television is animated film produced in mass quantities. Characters develop over several episodes, and if you are lucky, several seasons. To produce such shows economically, more emphasis is placed on dialog and music than intricate and expensive one-time action scenes (refer back to page 14 'Directing for television'). In addition, you can cut around actions without having to show it. Japanese Anime films are particularly good in putting emphasis on interesting layout designs and establishing shots with simple character movement and repetitive facial set-ups for dialog, saving full animation for key important shots. This way they economize without hurting the overall quality.

Editing for Children's Programming

Parent and consumer groups are aware that children are watching programming at a much younger age than ever before. Programs aimed at preschoolers have a particular set of rules all of their own: no fast cutting and little overlapping dialog; simple staging without a lot of inter-cutting; pauses placed in between important ideas for young minds to catch up; dialog and action paced in a gentle, non-threatening way; and large friendly colors with little shadows or effects.

FIGURE 76 Image from the TV show *Peep and the Big Wide World*. (Copyright 2004, WGBH Educational Foundation. 'Peep', 'Chirp' and 'Quack' were originally created by Kai Pindal for the National Film Board of Canada.)

Editing for Internet Downloads

Today many people around the world experience animation not in a theater, but on a hand-held computer or phone. This form of downloadable film has opened a brave new world to short film production. Because of the immediacy of the medium, only the most cutting edge and cleverest ideas reach the largest audiences, and that in the blink of an eye. To tap this audience, the filmmaker needs to be shrewd with their resources. You can't waste time on elaborate set-ups or subtle interplay of dialog. Your target audience is probably viewing in an open, noisy place, and has a short attention span. Small, visceral bits delivered with simple designs and staging will read better than a widescreen baroque spectacle.

FIGURE 77 *Time For Some Campaignin'* an animated short film created for the internet by JibJab. (Copyright © Jibjab 2008.)

Games

The design and creation of interactive games has evolved from the humble Pong game of the late 1970s to mega-budget high-quality productions that rival the largest Hollywood blockbusters in complexity. The project is divided into two parts: the body of the game itself, and the *cinematics*—an elaborate narrative introduction to set up the backstory and the mood. Depending upon your budget, the cinematics can be as high quality as theatrical animation. Some games producers will even use a higher-end animation program like Maya to do the cinematics rather than the actual programs used in the game itself.

The game itself is determined by the show's 'assets', i.e. the numbers of controls on your character's rig and the number of pre-made actions they have. Each character player has been given a library of modules—movements and gestures such as running, jumping, shooting, etc. The animator also needs to create bridges in between every conceivable pairing of actions. With the more realistic games, like war simulations, motion capture is used for much of the body actions.

FIGURE 78 Peter Foldes' *Hunger*—1974.

FIGURE 79 Image of live actor—2D rendered character *and* 3D digital image. (*Monster House* © 2006 Columbia Pictures Industries, Inc. and GH One LLC. All Rights Reserved. Courtesy of Columbia Pictures.)

Conclusion

This book originally ended with an image from Peter Foldes' pioneering computer animation piece, *Hunger* (1974). Its images look amusingly crude by today's standards. Halas and Whitaker mentioned the future potential of animating with a computer—that 'it inevitably and eventually will become an added tool in the hands of animators'. This present volume takes the prophesy of the potential to the reality of now. Computer animation, digital, 3D, whatever you care to call it, is the reality of our age. No longer theoretical, it is vital in the production of any animation today, including that which is still done by pencil and brush. The challenge to us in our present, and for our future, is to keep using the basic lessons taught to us by past masters like John Halas and Harold Whitaker. For their continued relevance is as vital to us as learning the latest software package. Being able to wield a hammer and chisel does not make you a Michelangelo; nor does raising a camera to your eye make you another Ansel Adams. So learning how to handle a specific software program, mastering the right buttons and levers to push, is only a small part of your animation education.

This book should not be thought of as the final word in your education in the art of animation. It but serves to point the way to a lifetime of study to master the medium. A career in the arts is never as simple as mastering some technique, then collecting a paycheck. It is a journey of growth and experimentation. Our hope is that by the time you are done reading these words, we will have helped you along in your first steps. Good luck!

Index